Writers on Writing

Alison Gibbs was born in Swindon, Wiltshire, in 1962 and has a degree in Literature from the University of Essex. She is Events Correspondent of *Writers News* and *Writing* Magazine and is a past editor of *Writers' Monthly*. She lives in Reading, Berkshire.

Writers
on
Writing

Alison Gibbs

ROBERT HALE · LONDON

ISBN 0 7090 5580 3

Robert Hale Limited
Clerkenwell House
Clerkenwell Green
London EC1R 0HT

2 4 6 8 10 9 7 5 3 1

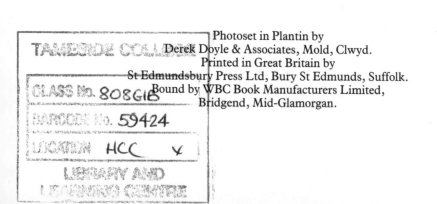
Photoset in Plantin by
Derek Doyle & Associates, Mold, Clwyd.
Printed in Great Britain by
St Edmundsbury Press Ltd, Bury St Edmunds, Suffolk.
Bound by WBC Book Manufacturers Limited,
Bridgend, Mid-Glamorgan.

Contents

Acknowledgements

I would like to thank all authors and publishers involved in the production of this book. Special thanks, however, must go to Barbara Taylor Bradford, who gave an interview that provided a sample chapter for the book, Yvonne de Valera, and Wendy Perriam who put me in touch with Jane Conway Gordon. For their help and encouragement, thanks also to Andy Mihil, Jan and Marcus Fisher, Alia and Barry Harrison and Jeff Barrell.

Lines from *A Woman of Substance* by Barbara Taylor Bradford, and *Not a Penny More, Not a Penny Less, Shall We Tell the President?, Kane and Abel, First Among Equals* and *A Matter of Honour* by Jeffrey Archer are reproduced with kind permission from the publishers HarperCollins Ltd.

Introduction

One in three people in Britain want to write a novel. If you are reading this book, you're probably one of them. So am I. What better way to understand how and what it means to be a writer than by asking the experts?

The experts featured in this book have nothing to prove. They've made it. They are there. But their success has not made them forget what it is like trying to write a novel and get it published.

These are generous people who empathise with the novice writer. After all, they face the problems of plot, characterization, dialogue, viewpoint and pace whenever they sit down at their desks.

But I've been constantly amazed how open they have been when talking about the creative processes they go through when writing their books. Hearing about their experiences has been a great help to me as I've struggled with my own novel.

I hope this book will help you with your own writing. I am sure you will join me in thanking all the writers who gave the interviews for this book.

Readers/writers – what would we do without you?

Alison Gibbs,
Reading,
November 1994

To David Lamb,
lecturer in English,
The Regent Circus College,
Swindon

1

Jeffrey Archer

One hundred million copies have been sold of Jeffrey Archer's novels; they have been published in sixty-three countries and translated into twenty-one languages. He was brought up in Somerset, where he went to school, and continued his education at Oxford, where he gained an athletics blue and ran for Britain.

After university, he was elected to the Greater London Council as its youngest member, and at the age of twenty-nine became the youngest Member of Parliament, gaining the seat of Louth in Lincolnshire. After five years in the Commons, with a promising career ahead, he took the advice of the Bank of Boston and invested heavily in a Canadian company called Aquablast. Unfortunately, the company went into liquidation and three directors were later sent to jail for fraud. On the brink of bankruptcy, shouldering debts of £427,727, he resigned from the House of Commons.

But his innate drive, very much evident today in his character, would not let him stay down for long. Aged thirty-four and unable to find a job, he sat down to write *Not a Penny More, Not a Penny Less*, a tale of four young men who having been swindled out of a million dollars, retrieve every last penny. Taken up by literary agent Debbie Owen, having been written at the home of his former Oxford principal, the

novel was sold to seventeen countries within a year. BBC Radio 4 serialized it, and there was a BBC television adaptation starring Ed Asner, Jenny Agutter, Maryam D'Abo and Ed Bagley jr. Over two million copies have been sold to date by Coronet.

His second novel, *Shall We Tell The President?*, sold over two million copies, but this was surpassed by *Kane and Abel*, arguably his finest book, which has sold over 3,250,000 copies in the Coronet edition alone. This was followed by his short story collection, *A Quiver Full of Arrows*. *The Prodigal Daughter*, the sequel to *Kane and Abel*, came next and then he wrote a novel which he says he was 'destined to write'. Set in the sixties, *First Among Equals* focused on four ambitious new MPs fighting to become prime minister.

A second set of short stories preceded the appearance of two more novels: *As The Crow Flies* (published in June 1992) and *Honour Among Thieves* (1993). *Twelve Red Herrings*, another short story collection, was published in July 1994. His hardback publisher is HarperCollins.

Jeffrey Archer was Deputy Chairman of the Conservative Party from September 1985 until November 1986. In 1991 he co-ordinated the Campaign for Kurdish Refugees, which raised £57 million. Various sources have indicated that he is a philanthropist, to which he will only reply, 'I fear I never discuss my philanthropic activities.' He was made a Life Peer in the Queen's Birthday Honours List of 1992.

'There are no short cuts to doing something well. Discipline is what matters. Don't give me that Muse rubbish. It's called hard work. If you have the gift, you're lucky, but don't tell me, "I lay around in bed but the Muse didn't come". Rubbish.'

So says Jeffrey Archer, whose novels have never sold fewer than 250,000 copies and frequently sell in millions. His books are simply unputdownable. He's a master storyteller, who started writing to make money when he was nearly bankrupted through a business venture. But the drive which enabled him to become an MP also allowed him to write his way out of financial difficulties.

With plots which twist and turn and time-frames which

frequently span decades, surely he writes detailed notes or at least an outline before he begins writing? 'Never,' says the immensely engaging Jeffrey Archer (or Lord Archer), who answers questions at machine-gun speed, attempting to make his craggy face look ogrish. But actually he's a bit of a wag, rather jolly with an almost fatherly air, which is not surprising as he has two sons.

So if he doesn't write an outline, how does he get started? Writers who spend days agonizing over their plots will no doubt be unnerved by his method.

Sitting in a folly at the bottom of his garden in Grantchester, he writes with a black felt-tip pen on yellow legal paper, from 6 a.m. to 8 a.m. 10 a.m to noon, 2 p.m. to 4 p.m. and 6 p.m. to 8 p.m., with two-hour breaks in between. 'I have a one-hour silver egg-timer which was specially made for me by Garrard's and is a wonderful machine because it does not allow me to cheat. I can't start at quarter past or quarter to and con myself into believing that I've done two hours' work. Most people who write con themselves the whole time.'

Working without an outline or notes means that he doesn't necessarily know what will happen in the novel. 'I know the story in the sense that *Kane and Abel* is the story of two men born on the same day, one with everything, the other with nothing, and they will meet. That's all I know. I never know what's on the second page. I never know what's going on in the next chapter. I never know where it's going to go. I have to pray every single page. But that is because I am a storyteller and not a writer.'

He is firm on this point. Although his conversation is peppered with admiration for Scott Fitzgerald, Herman Hesse and Graham Greene, he does not class himself in that league. Getting started doesn't trouble him. As if plucking a story out of the ether Jefrey Archer leaned back in his chair in his flat in central London and began: 'Once upon a time there was a girl sitting in a corner who was waiting for an interview when someone else walked through. She knew she had seen him somewhere before but it wasn't the person she had come to see....'

'I take it from there. I don't know where it's going; I pray.'

Jeffrey Archer continued:

'... And then she remembered. She didn't want to do the interview once she knew that person was in the room. She now had to work out how to get out of it....'

He paused, puzzled. 'I don't know where it comes from. I'm making it up as I go along. It's a weird gift.' He was on a roll:

'... But then it was too late. The young man appeared and she realized she would have to tell him. They'd had an affair many years before and she'd nearly killed him....'

'I don't know where it's taking me.' He leaned forward, clasped his hands in front of him, and when he leaned back, the words came again:

'... "Of course, you know my assistant because you damn nearly killed him." She didn't know what to say next....'

'I could take a three-second break and do you a totally different one,' said Jeffrey Archer. And then he did just that:

'His wife came into the room, walked towards the kitchen, stopped for one second and looked towards them. It wasn't her husband she looked at. The girl realized immediately she knew.'

'I just do it all the time. I don't know what the next page will be but I'll keep you turning the pages. When I am writing a novel, the first draft takes six weeks and is about 250 to 300 hours' work. When the first draft is finished I have a month's break. Then I go on to the second draft. The next draft will take four weeks, then three weeks and so on. The last draft will take fifty hours.'

Each of his books take between fourteen and seventeen drafts before he is satisfied and take two years from start to finish. How on earth does he keep the twists, turns and consequences for his characters in his head? He makes it sound easy. 'Don't forget I'm writing for two hours every two hours; I'm not doing anything else.' He also points out, 'During my broad first draft, there are no phone calls and no interruptions, as both my secretaries know my set writing hours. Heather word-processes my hand-written drafts triple-spaced so that I can write in my corrections.

'Once the first draft is done, I'm not in panic stations,

because what I panic about is constantly getting interruptions. When I've got the first draft the book is there and I don't mind my life being a tiny bit more disrupted but I still don't allow anybody to talk to me during my set hours. I wish there was an easy way but there isn't. *Honour Among Thieves*, for example, took me fourteen drafts and 1,400 hours, which was very, very hard work.'

As soon as day breaks, Jeffrey Archer is ensconced at his typewriter. 'Most of us are either larks or owls and I'm a lark. I'm in bed by 10.30 p.m., 11 p.m. at the latest. I like to be up at 5. a.m. My wife is an owl, who likes writing from midnight until 3 a.m. She finds it dark and quiet and nobody interrupts her. I can't say, "Young man or woman, listen to me, the way to do it is ..." The only thing I would say is that it is impossible in my judgement to do another job at the same time.

'A surgeon wrote to me once and said, "Would you be kind enough to read my book?" and I don't usually read books. But he was a distinguished surgeon and he'd given lifelong service to his country, so I wrote to him and said: "Dear Mr So-and-So, Did you write this between operations?" and he rang me up and said, "Yes – how did you know?" '

'I said, "There are some good chapters, bad chapters, middling chapters ... How insulting!" He said, "What do you mean by that?" And I said, "Totally insulting. How would you feel if I told you that I was about to start doing operations in between writing chapters? You'd be insulted – and I'm insulted by you writing chapters between surgery – now go away!" And he went away and did the book and got it published.

'What I am trying to say is that if you think you can mix novel writing with a normal life, you're conning yourself – unless you write from 6.30 a.m. every morning and it's separate from your normal life. Basically, I feel would-be writers should go away for five or six weeks and just do it.'

He added, 'I never write for newspapers when I am writing fiction. And that's something journalists can't understand when they are slogging away all day. But it's damn hard work writing a book. It's impossible to write a novel and write a

column. The brain, however big it is, wants to concentrate on something. You can say to it, "I'm going to concentrate on politics, as it's not connected with writing. But you can't say to it, "I'll write a column this morning about writers and in the evening I will write fiction," because the old brain will say, "Wait a minute – I gave you all the ideas this morning and now you want me to …" '

If anyone could see Jeffrey Archer writing his books, they would see and hear the ideas taking shape as he speaks aloud while he's writing. The drafts begin to take shape. 'Mine expand upwards whereas many people's go down. *Kane and Abel* will have started at about 110,000 words and ended up at about 250,000, because to begin with it's nothing but story.' As he expands the drafts, ideas spring to his mind, and he adds them to his work as he goes along.

He always takes great care over the openings of his novels and never underestimates their importance. The entry of Abel Rosnovski into the world is described thus: 'She only stopped screaming when she died. It was then that he started to scream.'

'I worked very hard at that first line. You've got to get the reader on the first page. I want people to say after *every* page, "I must stay with this." If I haven't done that, I've failed. I worked an average of four hours on each page but the first and last pages took ten hours each. I worked out every single word on the last page.'

Perhaps a characteristic that defines the successful novelist is the ability to engage and manipulate the readers' emotions and Jeffrey Archer knows exactly how and where to do this. Candidly, he admits he is alive to the effect certain events will have on the reader when writing them: 'In *Kane and Abel* you're meant to cry in three places: when Matthew dies, Kane and Abel touching their hats to each other, and Kane dying before seeing his son and daughter-in-law after years of estrangement.'

He pulls us quickly in to his characters but we have to care about them before we can get involved in their tragedies and triumphs. One of the ways he does this is by giving us quick-fire pen portraits early in the narrative. Page 1 of the

prologue in *First Among Equals* gives an example:

> If Charles Gurney Seymour had been born nine minutes earlier, he would have become an earl, inherited a castle in Scotland, 22,000 acres in Somerset and a thriving merchant bank in the City.

Page 2 includes a further snapshot:

> As no one had suggested for one moment that Rupert [Charles Seymour's brother] should enter the world of high finance, it was assumed once Charles left Oxford that he would succeed his father at Seymour's Bank: first as director and then in time as its chairman, although it would be Rupert who would eventually inherit the family shareholding.

Already Jeffrey Archer is teasing the reader through the use of the word 'assumed'. It almost suggests that Charles' career will not be the hinted-at bull market, and immediately a question springs into the mind of the reader: what will happen to Charles Seymour?

In *A Matter of Honour*, an initially hesitant, more sensitive and certainly poorer character is shown going about his business at the beginning of the novel:

> Adam parked his motorbike just off Ifield Road, aware that, like his mother's old Morris Minor, it would have to be sold if the Foreign Office job didn't materialise. As he strolled towards the flat a girl who passed gave him a second look: he didn't notice.

Even in his first novel, *Not a Penny More, Not a Penny Less*, the pen portrait immediately grips the reader, making us feel we know this character or at least can recognize him in others or in history:

> Henry Metelski was born on the Lower East Side of New York on May 17th, 1909, in a small room that already slept four children. He grew up through the Depression, believing in God and one meal a day.

But perhaps his most illuminating pen portrait is expressed in *Shall We Tell the President?*, when he describes his FBI character Mark Andrews in a single sentence: 'When he had the time to do so, he adored his wife.'

'I don't consciously sit down and do this,' Jeffrey Archer said. 'I'm such an amateur and a free spirit that I do what I want to do and pray it works.'

Writing a pen portrait, however, doesn't necesssarily mean putting the detail under a magnifying glass. Ever the realist, Jeffrey Archer acknowledges readers who have said that *Kane and Abel* moves too fast and could have been 500,000 words long. But he says that there isn't time for elaborate description in the type of book he writes, adding, 'The speed of the story is everything. It doesn't need three pages on somebody's glasses. Graham Greene might have spent that long on something like that or the way someone was sitting in a corner, perhaps. Wonderful stuff. A privilege to read and he does it with such style. But it isn't what my readers want – it isn't me either. *Kane and Abel* is already 500 pages without doubling it by describing every single detail.

'If you take Nobel Prize winners like Nadine Gordimer and Patrick White, they can't tell a story to save their lives. We're all told they are geniuses and that we have to read them because that's the way people learn and get better, don't they? They can't tell a tale. They can't begin, "Once upon a time", and grip you. Tell me who has been gripped by Patrick White. *Voss* is his best book but I still didn't read past page 58. There is a terrific difference between writers and storytellers.'

Jeffrey Archer's decision to choose an American and a Pole as the main characters in *Kane and Abel* came after he'd thought about it for a long time. 'If this story had been written a hundred years ago, it would have been about somebody French and somebody English and taken place in London and Paris – *A Tale of Two Cities*.

'So I sat down and began thinking about which countries would be equivalent in world terms. One equivalent was the United States, and I needed a European country from which people emigrated to the States. I considered Yugoslavia, Hungary and Poland, and chose Poland because the Poles had

a reputation for being brave during the war and they have a sense of honour.'

Can he see the characters in his mind's eye when he begins writing the pen portraits and throughout the novel? Does this 'idea' of the main character or characters include knowing everything about them – names, personal histories, clothes – before he starts writing? 'No. Sometimes I get bored because I can't get the right name for a character, and basically, description bores me.'

But what does interest him, and it's a theme which runs throughout his novels and through his main characters, is the nature of leadership. What makes a leader or a business go-getter? He asks the reader to consider these questions: 'Why did Mountbatten, a second son, become Chief of General Staff, Admiral of the Fleet and Viceroy of India when his elder brother didn't? Come on! It's because he was a king, a god. Why do James Hanson, Jimmy Goldsmith, Richard Branson or any of these people succeed. Background's irrelevant. If you've got it, you'll make it.

'I've met people who are utterly self-made men who get into the House of Lords and who debate with people who've been there for centuries. Where you're born is irrelevant when you're going to be a king. Kane and Abel are the same person. They are no different. Put Kane into a forest and Abel into Kane's home and you can see that they are the same human being.'

So are any of his characters based on real people? 'Oh yes – they are often real people.' He paused for a minute before adding quickly, 'Although not completely real people ... Kane and Abel are based on two people and I've always said I won't say until they've both died. One is dead, the other is still very much alive.

'In *First Among Equals* they are all based upon people I worked with in the House of Commons, but it would be unwise to let anybody know who they are.' He paused again then added, 'There's a bit of the late John Smith, John Major and Michael Heseltine in the novel. It would be hard to miss, really, wouldn't it?'

A certain name springs to mind on reading *The Prodigal*

Daughter, in which Florentyna Kane, daughter of William Kane, struggles and battles to become president, and an attempt is made on her life. 'Margaret Thatcher was about to become prime minister of Britain, and I thought, why not a woman as president of the United States? When I suggested it several people laughed at me. But I decided I would write the book so that when it did happen I would be light years ahead of them. I still think it would be a good thing for the United States to have a woman president.'

Lacking a plan means that Jeffrey Archer can follow a whim with some of his apparently minor characters. 'In *The Prodigal Daughter*, for example, Florentyna is coached by the wonderful Miss Treadgold, who is based on a headmistress of Cheltenham College where Mary [Archer] was at school. Miss Treadgold, was due in for three pages but I fell in love with her and thought she was wonderful and she lasted 200 pages.

'In *Honour Among Thieves*, Dollar Bill, an Irish Catholic, was due in for two pages but lasted until the end of the book. I was going to kill him off but I couldn't do it. By the third page of writing I wanted him to grow and in the end he dominates the book.'

He's not averse to killing off his characters if necessary, however. In *The Prodigal Daughter* the author captures the poignant moment when Florentyna makes her inaugural speech, wearing the brooch of her first husband, who was killed in a car crash. 'Good,' says Jeffrey Archer, with no compunction. 'She was making a great speech,' which leads him into a little story.

'Margaret Thatcher almost copied it, you know. She rang me once and said, "You wrote a book about a president in which you wrote a speech for the person concerned – can you find it?" It was a Saturday night and she said, "Where is it? Where is it?" She pretty much stole it word for word. She almost swiped the whole speech!' Ironically, he says that when he was working with her as a politician he never wrote a whole speech for her. 'I never knew anyone who did. You'd get a paragraph in, if you were lucky, or a few lines here and there.'

While he's driving himself through the fourteen or so drafts of his novel, he is constantly aware of the attributes he thinks

his novel should have. Snapping his fingers rhythmically Jeffrey Archer said, 'The novel must be fast, fast, fast – each line following the next.' He is firm on one point in particular: there simply is not enough time for characters to begin their conversations with conventional opening gambits such as:' "How very kind of you to see me, Mr Archer." ' Much better instead, he said, to get the characters speaking clearly and actively: 'Hello, my name is …'

'If you are writing a novel and you read it aloud, you will get a feel of how it sounds. What of course happens in real life, as you will know if you tape-record someone, is that one repeats oneself all the time, again and again. You can't do that in a book. You can't say:

"How very nice to see you."

"Nice to see you."

"You're looking so well."

"Am I? That's very kind of you, Mr Archer."

"Yes, I particularly liked …"

'It's what happens in real life but it shouldn't appear in a novel. when I'm speaking aloud, I might say to myself, for example: "She came into the room, she sat down. She had her arm on her chin and leant forward and started nodding. She said, 'M'mm' and laughed." I have to do it all like that.'

Jeffrey Archer is happy to admit that, in terms of dialogue, he has a great advantage in being a politician and a public speaker, but he also has another aid that gives him his 'ear', one available to everybody. 'I adore the theatre. Dialogue's not a problem. Critics have said that my books are narrative-driven and I think they are right.'

Not everyone is able to circulate with the kind of people who work at the House of Commons. But this is not important. 'You must mix with people – whoever they are. Listen to their voices, hear their stories, try and "feel' them. If you think you can write a great novel or short story sitting alone in a garret all day, all you'll write is a boring novel or story about someone in a garret. Get out and meet people. Get round the world, see people, travel, travel, talk, talk, listen, listen.'

His language is direct, constantly moving the narrative

forwards; there are no unnecessary adjectives. 'Well, that's me.' He says this almost apologetically, but an action novel has little room for flowery prose. 'There's nothing I can do about it. I'm not a very well-educated man in comparison with my wife. If I was as well educated as her the stories would be double the length and nobody would be buying them – at least, that's my theory.'

Jeffrey Archer's books are generally written from the omniscient narrator's point of view, but *As the Crow Flies* is an exception, constructed using the first-person viewpoint of several characters. The narrative starts with Charlie and ends with him. 'It was very brave to do eight first persons. I didn't decide to do that until the third draft. I felt it was an exciting way of moving the story on through the eyes of someone else.' He added, 'Charlie's very like me.'

Jeffrey Archer doesn't deny that he reveals quite a lot of himself in his books. 'You're bound to, aren't you? First books are always autobiographical. *Not a Penny More, Not a Penny Less* is very autobiographical. But, yes, of course you do, because otherwise how can you get the reader gripped if they don't believe it? Oh yes, authors are right in there.'

But does it make him feel vulnerable? 'Yes.' So how does he cope with it? 'You learn to live with it. It's not a problem. You get people coming up saying, "I know you because I've read your books." Well, perhaps they do ... you can see how I feel about women, honour and the way people are treated.'

But does the writer ever say, I'm going so far, I've revealed so much but I'm not going any further? 'I don't think the writer even knows that – not consciously. Colleen Smith, probably the best editor in New York, told me that a lot of what I reveal in my books is subconscious, coming out in a myriad of ways.'

A technique which often crops up in Jeffrey Archer's books is his decision to allow the reader to know in advance about incidents another character has set in motion that will affect another character. This is one of the ways in which the omniscient narrator engages the reader in the novel. 'The narrator is saying to the reader, "We know more than anyone else, we're really in there, you and I. We know what's going

on, don't we?" It's a great game to play to make the reader really believe, because they are moving the story on, not just you the writer. We are moving the story on together.'

In *Kane and Abel*, for example, Osborne suggests that Abel should not accept the first offer from the insurance company when his hotel burns down, but that he should go for a higher amount and give him, Osborne, a kick-back. Readers are left with a question mark as to whether Abel accepts Osborne's advice but the narrator hints that he does. The consequences of Abel's action reverberate towards the end of the novel. 'I tease the reader all the time. Throw in a sentence which makes the reader feel as if he or she can't afford to put the book down, every ten pages.'

Another of his techniques is to allow his characters to have conversations with famous people who were living at the times in which his novels are set. In *Kane and Abel*, for example, Abel discusses Communism with Senator McCarthy. But Jeffrey Archer cautions that the novelist 'must not take it too far. In real life it goes far too far'.

He tends to avoid flashbacks except when a character has a lapse of concentration in which he or she thinks fleetingly back to the past. This is because it slows the plot down, particularly in action novels. 'I only like going forwards. If you send the story backwards it has tremendous disadvantages.' In *Kane and Abel*, the action moves so quickly that Abel is dissatisfied with his wife on one page and divorces her on the next. 'Once you've made a decision you can't hang about. Once the dissatisfaction has set in, there isn't much point hanging around getting more and more dissatisfied. I think that's true to life.'

This quickstep of events is essential in a saga set over sixty years, but there's also room for a waltz. 'Well, you've got to slow some parts down. That's what gives a book pace and is done purposely. In the first chapter of *Kane and Abel* in the original draft the chapters were all the same length, about thirty or forty pages, which was noted by the editor. She said, "What you need is chapters of uneven length to build the tension," seeing clearly where we could make the novel more dramatic. I agreed and rewrote it, because I could see that if

we had had Kane for thirty pages followed by Abel for thirty pages, it would have been difficult for the reader to remember who the other person was.'

The author comments, 'Well, that was only my second book. I was still learning.' He grinned. 'Don't show this chapter to Freddie Forsyth. There is only one difference between this book and *The Day of the Jackal* – Archer is the better writer!'

However successful he may be, Jeffrey Archer possesses the humility to consider criticsm. 'A drastic change was initiated in *Kane and Abel* by my children's nanny. She read it in draft form and thought it was wonderful but pointed out its one weakness – Kane and Abel should only meet once. I knew at once she was right, although previously I hadn't seen it.'

Editing his work as he goes along, he says, 'It's rare that I put lines through my work as I am building up the narrative the whole time, but I sometimes see myself repeating things and tell myself that they must come out. Often paragraphs are in the wrong place because I am not writing to a plan.

'If I've been describing a character for three pages and four pages later I say that the way she took off her glasses tells you a little bit about her character, I can see that the description should have been at the beginning. Two days later I might decide to use the glasses again in some way. When I see it on the next draft, I might say to myself, Well, that's a lovely idea but it needs to come out there and go here. I'm getting ideas about the human being as I am writing. I just pray that the brain is still good enough to pick up any inconsistencies.'

Even the maestro has lapses, however. In *The Prodigal Daughter* the narrator tells the reader that Florentyna worked with a girl called Maisie on the glove counter of a department store. In *Kane and Abel*, the novel prior to *The Prodigal Daughter*, Florentyna takes the name Jessie Kovats when she elopes because, the narrator tells us, it is the name of the girl she worked with on the glove counter.

'An error,' Jeffrey Archer readily admits. 'O. Henry has a great story about falling in love with a girl called Maisie, which makes me wonder if subconsciously I gave the girl the name for that reason.' A well-read man, despite his denials, his

favourite writers are Scott Fitzgerald, Munro, Maupassant, Graham Greene and Evelyn Waugh. 'They are all storytellers.'

Story-led as his novels are, they are also as accurate as he can make them. The drive to get the story out means that he doesn't stop to check his facts as he works, saying that, at first, it's just the story he is interested in. 'Usually, I have a good young researcher who goes over the novel with a red pen and tells me where it's incorrect before my publishers, HarperCollins, see it.'

When he's finally happy with his work he sends off the typescript to his editor, Stuart Proffitt. 'I've had four different editors over the years and they've all been different. Stuart tells me if he likes something – or doesn't – and I consider doing something about it. HarperCollins still find mistakes, however, and have someone who goes over the novel again, particularly on the fourteenth and fifteenth drafts.'

Jeffrey Archer no longer has an agent (except in Japan), although he did in the past. 'I do three-book deals for the whole world with HarperCollins – they've got the whole world, so why have an agent?' All very well for a famous writer who has the clout and knowledge to get the best deal possible but should a new writer have an agent? 'I would advise it strongly. You have no hope without an agent. I used to be in twenty-three different languages in sixty-seven countries dealing with twenty-three different agents. Now I only have Tom Mori in Japan because he is exceptional and the most important agent in Japan, who's been with me for many years – and Japan is an awfully long way away.'

Jeffrey Archer had an agent for the first eight or nine books. 'Every time she brought a book forward I realized exactly how much money she was getting and what the terms were. When I decided to do a three-book deal for the whole world it seemed silly to ask her to do what I could do for myself. Perhaps I should have done it a few books earlier. But I've only ever had one agent and we parted on very good terms and have remained friends.'

New writers may have difficulty finding an agent. One way is to ask any writers you come across who their agent is or if they could recommend someone. Some writers dislike passing

on this information, because they don't want to see him or her
weighed down by unsaleable manuscripts, invariably sent
without return postage. But if you don't try, you'll never
know. Jeffrey Archer reminded readers that he's got no time
for would-be writers who put their faith in the Muse. 'You've
just got to get on with it.' And, to a great extent, in sympathy
with Barbara Taylor Bradford, he says that the way to learn to
write is simply to do it.

He does get a bit hurt by people who think it's possible to
write to order. 'There is a Member of Parliament and a
journalist who once declared in a column, "My friends tell me
I should write a Jeffrey Archer book and make a fortune." He
wrote the book and it sold, 3,000 copies. But did he have the
manners to apologize and say it wasn't as easy as it looks? Not
a jot.'

2

Beryl
Bainbridge

'I never make any characters up. I always have to base them on someone I know. Nobody's ever objected. Or I make an amalgam of several people. I could make characters up, but I don't want to. Why bother?'

Beryl Bainbridge's frank and direct approach to questions contrast with the surreal and fantastic events that often occur in her novels. In *The Bottle Factory Outing*, which won the 1974 *Guardian* Fiction Prize award, Brenda is threatened with a gun by her mother-in-law. This must be pure fiction, surely? 'Actually, my mother-in-law did threaten me with a gun at one time,' says Beryl. 'She was old and she thought I was her, and she came to punish me/her for leaving her children. She left four children and ran off to be a painter.'

In the novel, Freda and Brenda work in an Italian-owned wine-bottling factory in London, and arrange an outing for a picnic at Windsor Great Park. Freda fancies Vittorio, the manager, who already has a secret fiancée, and is largely uninterested; Brenda is plagued by the unwanted attentions of Rossi (the manager of the bottle factory) despite his having been warned off by Freda. On this October day, the men play football in the park and watch animals copulating in the zoo. The outing culminates in the death of Freda, who falls backwards in a wood breaking her neck.

The incident is never quite explained in the novel – did anyone murder her? The chief suspects are Vittorio and Rossi. Though essentially honourable, the members of the group decide that they do not want to bring shame upon their family by an investigation into Freda's death – a conclusion to which Brenda gives her tacit approval. In scenes that involve the dead Freda being dressed up and driven bolt upright through London in a car, they decide to dispose of the body in a barrel of brandy and have it shipped out of the country, and out of their lives.

What sparked off the idea for the novel was a funeral. Beryl Bainbridge opened her front door in north London one morning and noticed a funeral across the road. 'An idea began to form in my mind and I began thinking about my friend Pauline, who had fallen for a chap called Vittorio, and I thought about myself, and then off it went.'

Beryl's black humour makes it possible to empathize with the characters. Beryl explains, 'I worked up the road at the bottle factory for a while. The old people's flats opposite my house are where the Greek lady used to sing on the balcony and which I used in the novel. Pauline, who also worked at the bottle factory, is Freda in the novel, and used to live on the corner.'

Other elements from the novel are based on reality: 'I did live on a farm for a bit, and Maria and Giovanni actually existed. There was a box at the bottle factory from which employees could get old clothes and we did go on an outing. Pauline did go on the Queen's horses, we did go to the zoo and we did have a football match. When I was writing the novel, the easiest thing to do was to jump to the match, and the events afterwards.' Arranging to have a body shipped out in a cask of brandy appears unbelievable at first, but Beryl points out that Nelson was brought home in this way, which gave her the idea. 'All the bits fitted in – none of it is made up,' says Beryl.

'Coming from Liverpool, most people are very articulate and humorous, however uneducated. Many comics such as Arthur Askey and Ted Ray came from Liverpool and it's not accidental that it is the home of many modern poets such as

Roger McGough and Adrian Henri. There is always a twist at the end to what they are saying. They'll say something profound but turn it into humour as well. I was brought up in that environment; in the depths of rage there would be a crack in the middle.'

Beryl didn't think her books were funny at all when she first started writing. 'I didn't mean them to be. Gradually I began to see the humour concerning certain incidents and started to use it deliberately. There's black humour in *The Bottle Factory Outing* because nobody really knows who's killed Freda, who has broken her neck in the woods and thereafter has to go round sitting up in the car dressed up. It seems to me to be a logical extension of letting your imagination wander just a bit further. It's perfectly possible. If you knew someone like Freda, you'd see what I mean!'

She bases her characters on people she knows. 'Most of the male characters are my father. The *Young Adolf* character was my father, as was Captain Scott, in some ways. *A Quiet Life* was based on my brother and myself, and *Harriet Said* was about my childhood. *An Awfully Big Adventure* was my story of working in the theatre as a young girl.'

Does the honesty which allows Beryl to talk about the creation of her characters make her feel vulnerable? 'Oh no, no, because I think I was fairly neurotic before I wrote and it just wiped it all out. It's just like psychoanalysis. I think most writers write out of their experience but they don't say so. They pretend it's all made up. But I think that's rubbish. Even science fiction is not simply "made up".

'I don't even believe in the imagination in the sense of it being something that comes out of the sky. I think it's a hotchpotch of things. My grandson Inigo wasn't born with an imagination – he will accrue one through remembered bits of voices, songs and experience and that will turn into his imagination. He's not born with it like blue eyes.'

Beryl sees a correlation between acting and writing in the sense that both professions require the practitioner to reveal something of themselves to strangers. 'It's not that difficult if you are a show-off and it's something you've always wanted to do. My only real reason for writing, in the beginning, was to

make sense of my childhood. There was no way that I was going to hide anything. I wanted to reveal it all, not for anybody else but for me.'

Beryl says that she couldn't have written about her parents had they been alive. 'Once they were dead, I could do what I liked. I mind about exposing somebody who is still alive, but I don't think it matters a damn about exposing yourself at all.'

Some of the characters Beryl writes about are very much alive, in particular, lovable Alma in *Injury Time*. 'I've got a very dear friend called Maggie who is Alma in *Injury Time*, the one who arrives drunk during the siege. Maggie is exactly like Alma. She totters in and says, "Have you got a little drinkie, darling?" and when she read the book, she said, "Which one is me, darling?" My other friend, Pauline, on whom I based Freda, did know it was her but didn't mind because she thinks she wrote the book, and I described her as being a stone lighter than she actually is, so that was all right.'

Some readers of this book might find it hard to write about painful episodes in their lives and fear hurting others. Beryl says, 'When I teach people on courses they all say that they write from their own experience, but are blocked because they don't want to hurt somebody. My theory is that you should write as if nobody will ever see it. Write it as absolutely true as it was and put it away for a month. Then get it out, look at it, and change names, places, attitudes and mannerisms.'

Readers may even contemplate writing about a member of their family. 'Try altering the sex of your character,' suggests Beryl, 'although even then you could still be caught out and accused of libel – but there is a way. I look for plots in a newspaper, and many plots in my novels come this way.' The plot of *The Dressmaker*, and *Harriet Said*, both came from newspapers, for example. *Injury Time*, although set in Beryl's own home, was based on a newspaper report of the murder of a woman's husband, children and aunts at their home in the country. 'Just write your own life round it and the novel moves further away ... The process of writing will lead aspiring novelists on to something else; it always does. Never disguise it to yourself.

'When I wrote *The Dressmaker*, for example, it was about

my Auntie Margo, Auntie Nellie and the girl-next-door, Sybil Santer, who is called Valerie Manders in the novel. All the way through the book I wrote about her under her real name, but my editor, the writer Alice Thomas Ellis, said to me: "Sybil's alive somewhere; you'd better change the name." I hated having to do that; I couldn't have written the book at all if I had called the character Valerie Manders from the start.

'There are two rules of thumb about writing. One is that you should not write about an experience until long after it's happened and the other is that you should write about it immediately. I've used both methods. Obviously, my novels about my childhood were written a long time after the events had happened, but *Injury Time* was written quite quickly afterward, and *Sweet William* was written soon after it happened.

'*Sweet William* is more or less word for word as it happened and my daughter Rudi is the baby at the end of the novel. She still sees her father, "William", in America and he has never objected to being written about either. The character of Edward in *Injury Time*, and Ashburner in *Watson*, was based on my solicitor, who was supposed to be reading the book for libel, and then found himself in it. He recognized himself but he didn't mind either. There is also a character called Muriel in *Injury Time*. "Simpson" got divorced from her quite soon afterwards – although I don't think it was anything to do with me.'

An accident was the catalyst for *An Awfully Big Adventure*. 'I was tidying some books at a precise time early in the morning. The piles of books fell over, I knocked myself out, and when I came round went downstairs and rang what I thought was my mother's number – who had been dead for fifteen years. Brian, the speaking clock, answered.

'In the morning I began to think about "The Girl with the Golden Voice", which was what the speaking clock was called when I was a child. I rang up British Telecom, who told me that the girl had won the competition to be the speaking clock in 1937 and had then run off to America and nobody knew why. Before she went, she got a job compering *Henry Hall's Guest Night* on the radio and failed in her attempt to join the

BBC rep. company because she was untrained.' In the novel, the young girl is always phoning her 'mother' who in reality is only telling the time. 'I then started thinking about a possible link with J.M. Barrie's *Peter Pan* story.'

Writing about people she knows is a technique that Beryl has used from the beginning. At the funeral she attended in 1994 she met the two wives of a man she had written about in her first novel, '*A Weekend with Claude*. 'They had both read the book and told me how close I'd got to him.'

Perhaps Beryl's friends have not objected to her writing about them because they realize they are only part of, and not the whole of, the story. Characteristics such as love, hate, fear and jealousy are states of mind which Beryl often discusses through her characters, which add another dimension to the story. Readers can therefore respond to Beryl's characters on several levels. Even if the events seem fanciful – such as the hiding of a body in a barrel of brandy – readers can understand the temptation to sweep a mistake under the carpet.

Beryl comments, 'I think this is how you can write about people, because we are all exactly the same really. We all have the same good things and the same bad things. None of us is unique. What goes on in us all is universal; it's only how we perceive each other which makes the events.'

Beryl writes for herself and not for her readers in the first instance, as she thinks that would be too limiting. One of the questions she does consider is viewpoint and tone of voice, perhaps the most difficult things for a writer to get right. Beryl asks herself who is telling the story. Is it the main character, the author, or every character in the novel? 'Once or twice, and I prefer it, I've written a novel in which the author doesn't come into the story at all. In other words, instead of the author saying of a character, "She felt upset," I've shown the character as being upset through dialogue, or I have described another character saying that she seemed upset.'

Examples of the different tone in Beryl's novels can be seen by comparing *Harriet Said*, which she says was written in the voice of the person she was then, and the detached observation of *Young Adolf*. *An Awfully Big Adventure*, which was shortlisted for the Booker in 1993, is written in the most

detached voice Beryl has so far used – this an effective device to convey the girl's lack of awareness of the havoc she is causing.

The novel is based on her early life and the people she knew as a sixteen-year-old trainee actress at the Liverpool Playhouse. Memory plays an important part in getting the right tone. 'Once you begin to look back and remember, you know that there's such a thing as total recall – you even remember the colour of things, or you think you can.'

Getting the right tone was essential in *The Birthday Boys*, her novel written from the five different viewpoints of Captain Scott and his men and their attempt to get to the South Pole. Beryl explains, 'The first voice was easy because it was of a petty officer, a vaguely working-class bloke from Cardiff or Swansea, which was easy for me because north Wales is just next to Liverpool.

'It was more difficult when it came to creating the voice of Captain Scott and the officers, so I used blown-up photographs so I could study their faces, read their letters and watched the John Mills film to get a rough idea of who they were. Writing a voice for a character is a bit like acting. You put yourself into a role and then start writing it down.'

When Beryl sits down to write her novels she has to get the plot first, despite basing her characters on people she knows. 'I have to do it this way and then think of all the people who might fit into it. I can't suddenly meet somebody and know them for two years and think that they might be good in a book. I've got to know them for years otherwise I don't think they come out as real.

'When I was writing *Winter Garden*, the name Ashburner suddenly came into my head – God knows from where – and ages later, when I was writing *Watson's Apology*, Ashburner appeared again. Ashburner kept on lighting fires, which I hadn't expected him to do either; it just goes on like that. There was also a character in *Injury Time* called Freeman, who later appeared, under another name in *Winter Garden*. The irony was, of course, he was so unfree and tied up in himself. As a writer, I get all sorts of funny connotations coming from names.

'The subconscious works all the time. When I wrote *An Awfully Big Adventure* (a phrase uttered by Peter Pan) I discovered that Barrie was a great friend of Captain Scott. One of the last letters written in the tent was to James Barrie, which set me thinking about lost boys and Never-Never Land. There is something subconscious going on in your mind all the time which you don't recognize.

'Another difficulty is that the more books one writes, the more solitary life becomes, and one never meets anybody ordinary any more. One becomes out of touch with background and roots. By the time you look out of your window, there's another world out there. *Injury Time* and *Sweet William* are the only "modern" novels I've ever done. The others are all set in the past – often the fifties. Now, I prefer to go even further back, to 1840 in *Watson's Apology*, for example.'

Beryl thinks she has exhausted her own past and therefore wants to delve deeper into history. 'Today uses a different language and ideas, which I don't particularly know much about, and what I've seen doesn't grab me. I don't find it interesting. In another twenty years I might do it, perhaps, but not now.'

Beryl considers time an important feature in her novels, explaining that she has to know the sequence of events before she starts writing. If the time-span of the novel goes beyond three months or a year, Beryl thinks she's in trouble, on the grounds that if she shows a character going upstairs, she can't allow herself to leave him there, but has to bring him down again. *Watson's Apology* spanned from 1840 to 1884, for example, and she found that the only way she could handle such a large period was to divide it into four parts: Spring, Summer, Winter and Autumn, and so avoiding the limitations of a linear progression.

Setting is a further consideration, and as with her characters, her everyday life blends into the narrative. 'Some of my novels are set in my home in north London, so I *really* know which rooms I'm going into when I'm describing them, whilst others are set in homes I knew as a child.'

Occasionally, Beryl finds that when she is writing, a word

imprints itself on her brain and she finds she is using it far too much throughout the book. In some ways, the word may act as a symbol of the entire book. 'It must do but it's all deeply buried. I don't know that I am repeating this word as I am writing, but I seem to keep using it anyway – and it's always a different word I focus on in each book.'

The symbolism in Beryl's novels should be approached carefully, however. A student was talking to her about the melting walls in *Young Adolf*, but Beryl quickly realized he had not interpreted her ideas as she had intended. 'When I lived in Liverpool we had quite a big house and we had lodgers and so did the next-door neighbours. The children's rooms were on the top floor but there were no fire escapes. We seriously considered knocking a hole in the side wall of the bedrooms and then just thinly papering it over so that if there was a fire the children could leap through. In *Young Adolf*, I didn't bother to explain that but just said that people leapt through walls. The melting of walls was described in the thesis as being very mysterious.'

Making connections with words is another characteristic which Beryl notices her brain is making as she is writing. 'In *The Birthday Boys*, for example, the symbol which keeps cropping up is birds. There's Robert Falcon Scott, Birdie Bowers and a sequence I made up about this mythical bird. None of the bird imagery was deliberate. It's a subconscious use of language.'

Beryl's writing methods have changed over the years. Previously she used to write a pencilled version in about four months, then she became a one-finger typist before graduating to the word processor. 'I've always written quite quickly. I plan the novel for a few months but the writing time doesn't take very long. This is mainly because I don't go out or answer the phone, hardly eat and smoke a lot, so it's got to be done quickly otherwise I'd be ill.

'Once I get going I'll get up at 6 a.m. and work until about midday and then perhaps I'll have a nap in the afternoon. When the children were smaller I'd probably not do anything in the afternoon except get the tea and things like that. Once they were in bed at about 7 p.m. I'd work through the night

until about 3 a.m. and get an alarm call for 6 a.m. and start the same thing again. As I get older, I can still work all through the night if I'm interested, but I'll nap in the afternoons.

'The odd thing about writing is that when you're doing it you know exactly what is happening and when you're not doing it you forget how it's done. When you start a new book the beginning is the longest period of all. It's a bit like childbirth; you forget what it was all about and have to start all over again. Once I've got the first chapter, it gets quicker. I make notes about the story before I begin writing. What I like to do is work out how many words and then chapters I am going to have, making notes of what I want in each chapter. That takes up a lot of time. After that, it's a process of getting down to it.

'On the word processor, I keep all the different versions, as I only do one draft of my novel. I can't work on the second page until I've got the first page as right as I can get it. It means doing about six drafts for each page, but once I'm satisfied with that page, that's it, more or less, and I go through it like that to the end, although I cut all the time. The average length of my novels is between 70,000 to 80,000 words, although *Watson's Apology* is about 110,000 words.'

Taking up to six drafts to get a page right is exacting work that requires patience. 'I realize that I'm saying something in my head and I've put it down on paper but can now see that it's not the right word, doesn't sound right, is in the wrong way round or could be replaced by something else. I do this until I've got the tone for the book.'

Occasionally Beryl experiences a high as she is writing. 'That comes when a piece is going really well and I suddenly think, "God, that's good." For about a page it will almost write itself and it doesn't need rewriting – which is wonderful. Aspiring novelists might like to know that the great secret is to get your first page as right as you can, except for the last lines, so that next morning you've got something to work on. Starting again cold is awful, unless it's going well, when it will take off. When the work is up and running it gives you the confidence next time to write with energy for quite a long while, but you know that your energy will go and you will flag again.'

Enormous concentration is required to be a writer and Beryl

doesn't understand how some writers can do three hours in the morning, play tennis, see their children, and then go to the theatre in the evening. 'To me, that would mean another six months of having to do it the next day. I can only produce a novel by writing it until I fall asleep in front of the telly and then go back to it.'

Beryl points out that structurally in three of her books – *Harriet Said*, *The Bottle Factory Outing*, and *The Dressmaker* – the plot turns full circle at the end to come back to the beginning. *The Bottle Factory Outing* begins and ends with a funeral, for example. 'I couldn't think how to structure that novel, particularly in deciding where the story began, but it was easy once I had thought of the funeral tie-up.'

On the whole, Beryl finds writing the endings of her books difficult. 'Sometimes my publisher, Colin Haycraft at Duckworth, gets quite cross with me and says he doesn't understand what I am talking about. I explain, but often he says it's too vague. But on the other hand, there are people writing theses on my work, although I haven't really dared to look at them too much, including one called *The Irony of Beryl Bainbridge*.'

So how did she get started? 'I was born in 1934 in Liverpool and attended the Merchant Taylor's school, a private school. I was all right at English but wasn't very academic. But I was a show-off, because my parents argued a lot and I always had to play the clown. There was a radio when I was growing up, which I listened to a lot, mainly the Third Programme, but no television, of course. The wireless was important. The first thing I did when I came home from school was to turn on the wireless in case my father came in and had a row. We didn't want the neighbours to hear.'

Like many girls, Beryl kept diaries and wrote stories, which her mother encouraged, and then she saw an advert in the local paper saying that BBC Manchester required child actors. Beryl got an audition, as did Billie Whitelaw, Judith Chalmers and Judith Chalmers' sister. She began and finished a novel but regards it as a childish attempt, based on the Chinese opium war, a subject about which she knew nothing. At fourteen, she sent some poems to Faber & Faber and Chatto &

Windus, who encouraged her to keep on writing, although they couldn't do anything with her work.

'At sixteen I went to the Liverpool Playhouse as a student and then as an actress, followed by rep. It was a very good education after the war because all the actors had just come back from World War II and wanted to learn their jobs again. Students didn't just make tea; the actors gave us booklists to read and sent us to art galleries and matinées of plays at other theatres.

'When I was twenty I fell in love with a painter, Austin Davies. We got married and had children, and I gave up the theatre. I didn't really miss it as I'd never really liked it. I didn't mind doing it if I was acting in a production, but I hated rehearsals. I was nervous and shy.

'After I'd had two children, Jo-Jo and Aaron, my husband walked out and I couldn't afford baby-sitters. As I'd always written, I wrote my first adult novel in about 1963 but put it away and forgot about it. In 1965 I moved to London and met a writer who suggested that I should send my novel to his agent. The agent suggested more or less that I should get a job at Woolworth's.

'However, I wrote a third novel, *A Weekend with Claude*, and sent it to New Authors, an imprint of Hutchinson's. As soon as New Authors had published it, the writer went automatically on to Hutchinson's. I wrote another novel, *Another Part of the Wood*, which was also accepted and published, but then stopped writing again in 1968. I'm not sure why ...

'I think it was because I expected then that if you had written a novel and got it published you were immensely respected and people told you to get on with writing another. But nobody did so I didn't do anything about it ... and I didn't get any money for it, anyway.

'But in 1970 one of my children was playing with a boy called William in the road outside the house and his Mum rang up to tell him to go home. She asked my name and said that she was Alice Thomas Ellis and also came from Liverpool. She said, "I've read two of your books which I don't think much of but have you got anything else?" I told her that I had a lost

novel somewhere but could perhaps look it out. That novel was *Harriet Said* and it was accepted by Alice who was then an editor at Duckworth's and married to the publisher Colin Haycraft. They told me only to write about what you know, keep to a few characters and get on with it. I then wrote a book a year for them for six or seven years and am still with them.'

Beryl is ambivalent as to whether she would have continued writing after *A Weekend with Claude* and *Another Part of the Wood* were published if she had not been encouraged. 'I possibly might have done, but what I would have produced wouldn't have been the same sort of books. I was lucky to stop writing and then start again with a different perspective. Alice Thomas Ellis seemed to know exactly which way to push me as a writer, probably because we came from the same sort of background in Liverpool. If I'd had an editor from London it might have been different.

'I like being edited. I'm not one of those writers who say don't touch it, it's done. I rely on being told whether it's any good or not. But after the years, if you really go over and over your work, which I do, you begin to know how to edit yourself. You know when something is right and when it isn't. I don't have an editor in the sense that I did in the old days. I show my publishers my work but I don't rush along with a chapter and ask what's wrong with it, as I used to.'

Beryl acquired an agent – Andrew Hewson – when she started writing plays and film scripts, but she didn't feel she needed one at Duckworth's. 'I don't think in those days that an agent was as important.'

She gave up writing for a time when she met her youngest child's father, who was an established writer in America. Only when the relationship broke up did she start writing again. The irony is that had her marriage survived we might not today be able to enjoy Beryl Bainbridge's talent. She is divorced with three grown-up children and three grandchildren. The author of fourteen novels, two works of non-fiction and five television plays, Beryl has had *Injury Time, The Dressmaker* and *An Awfully Big Adventure* shortlisted for the Booker Prize. She is published by Penguin in paperback.

3

Barbara
Taylor Bradford

'Anybody who says "I'm going to sit down and write a best-seller and become rich and famous and another Barbara Taylor Bradford" is not going to do it. It's the wrong motivation. You have to want to do the work more than you want to do anything else. You really feel the need to sit down and create this story that is so compelling within you that you have to get it out.'

So says Barbara Taylor Bradford, whose books have sold over 48 million copies in eighty-four countries and been translated into twenty-eight languages. 'If you try and invent a formula and write a novel just to make money or write a best-seller, it's not going to work. Nobody should attempt to write a novel unless it's absolutely essential to their well-being. It really has to come from the heart – that's why my books work.'

But what separates those who have a burning desire to tell a story from those who succeed as novelists? 'Apart from the ability to write, imagination and talent – which are all givens – you've got to understand what makes people tick. If you don't have that, forget it. And you must have an enormous compassion for other people. You have to be able to understand their pain, their sorrow, where they are coming from and all their anguish.

'True compassion is to put yourself in their place and truly understand what each character is feeling at that moment. A novelist has to be able to do that. I have to "be" Emma Harte in *A Woman of Substance* or Maximilian West in *The Women in His Life*, or Rosie in *Angel*. I have to be the main character. I have to get inside their skin.'

So what comes first when Barbara is thinking about writing a novel – character or plot? 'I start with character,' she says. 'I see the protagonist in my mind's eye and I say, OK, this is Emma Harte or Maximilian West or Rosalind Madigan, for example and I ask myself; Who are they? What's their problem? Where are they coming from? What's their drama? What makes them interesting enough to write about?

'I question myself about the drives and motivations of the main protagonist because character is destiny. I read an interview with Graham Greene in which he said character is plot, and for me that's absolutely true. What a person is, what their inner strengths and weaknesses are, will be their destiny and propel their life and therefore tell the story.'

Barbara says she is particularly drawn to characters, because that's the only way she is inspired to write. 'I wrote four other books, which I didn't finish, before *A Woman of Substance* was published in 1979. Maybe those unfinished books didn't work for me as a writer because I was starting with plot and putting characters in it.'

But what advice can Barbara give to novice writers aiming to create a memorable character? 'The characters must have distinct voices. If they all sound the same, forget it. The way you get a distinctive voice is by building this in to the character of the person by absorbing their speech pattern, absorbing the way they speak.'

An example of how character can be partly defined by speech can be seen in the passage in *A Woman of Substance* when young scullery maid Emma Harte is tramping through the mist on the Yorkshire moors en route to work. She sees a man approaching and is terrified. But when the 'monster' speaks he imprints his voice on the mind of the reader.

'Faith and if it's not me good fortune, to be sure, to be meeting

a spry young colleen on these blasted moors at this ungodly
hour. T'is the Divil's own place, I am thinking, and not fit land
to be a-wandering in, on this cold morning.'

To reinforce the reader's sense that this will be a major
character in the book, Bradford writes: 'He had a strange
voice, but it was lovely, musical and lilting, and different from
any voice she had heard before.'

Compare this with Emma's own voice when she asks
Blackie (the 'monster') a question: 'Why do you yer want to go
ter the Hall then?'

As the book progresses, so do Emma's speech patterns and
vocabulary. Later on in the novel, when Emma has become
the millionairess owner of Harte's department stores, a
publishing company and numerous other interests, she uses
language quite differently. In one scene, Emma has invited the
members of her family (from many of whom she is estranged)
to Pennistone Royal and is about to tell her daughter Edwina
who her true father is:

> 'Why did you want to see me, Mother?' Edwina responded
> with icy disdain. 'I'm quite certain you didn't ask me to come
> up here to compliment me on my dress.'
>
> 'That's perfectly true,' Emma said. She smiled faintly.
> Edwina had not softened with age. 'Let me ask you a question
> before I answer yours. Why did you accept my invitation to
> come here for the weekend?'

Edwina tells her mother that she felt it was a command rather
than a request and that her son, Anthony, Emma's grandson,
wanted to see her. Emma's response is not the response of the
young scullery maid from the moors. It is the voice of a tough,
hardened businesswoman, who is also a lady: 'When your
Uncle Winston effected a reconciliation between us in 1951, I
hoped we could become friends. But it's always been an armed
truce, hasn't it?'

Instead of the short, gritty syllables of northern
working-class dialect, the Emma of 1978 speaks in the long,
languid, considered sentences of a person who knows she has
no need to rush her words as she knows that she will be
listened to.

Creating fresh and distinctive voices from which readers can recognize the character without even seeing his or her name on the page, is a particular strength. 'I hear voices in my head,' says Barbara. 'And I guess I start doing that when I am forming the characters of the people in the book. Getting a distinct voice for each character comes from knowing the characters intimately but it also comes from having a very good ear.' Tough, gritty Yorkshirewoman that she is, she says she can't explain why she has an ear for dialogue. With a stab at an explanation she says, 'I hear voices because I've known a lot of people, I suppose.'

Maybe she uses a tape-recorder to keep the voices fresh in her head? No, she doesn't, 'but I do have a good memory.' Fair enough, but does she have any tips for beginner writers aiming to create believable dialogue? 'The way I write dialogue is that I plan a scene so that it leads up to dialogue or maybe the scene begins with dialogue. Dialogue has to do many things. It must move the plot along, delineate character and give information – so I formulate my dialogue to do all those things.'

But giving her characters a voice is only one way of making them come alive on the page. Barbara puts details of each character on a separate postcard – which she keeps in a shoebox. Down on the postcards go: the character's name; physical description; characteristics; and personality. She rarely returns to the postcards once she has created them but they are a useful tool, particularly when she is working on a book with a long time-span, with characters who are developing as the plot progresses.

Creating memorable characters is a mysterious business; some writers base them on people they know. Barbara says, 'I'm not sure where they come from ... I don't base my characters on a particular person but what I do is borrow little bits and pieces from people. I know many people, and my husband and I do a lot of travelling. If I see something characteristic – such as somebody pushing back their hair all the time or having perpetual nosebleeds – then I may borrow this.

'I had the character of Rosie from *Angel* in my mind for

some time because I had thought of the character when I was writing *Remember* at Shepperton Studios. My husband was producing *To Be the Best* as a mini-series and I was using an office there. I looked out of the window one day and saw a lot of people in medieval costume and discovered Kevin Costner's *Robin Hood* was being filmed.

'I watched a battle scene and suddenly the character of Rosie reappeared in my mind (although I didn't know her name at that stage). I started thinking about a character I'd thought about a few years earlier from a book which I'd never finished two or three years previously. She was an American woman involved with a French family living in a château. But I'd kept all my notes on the characters of this unfinished novel, the situation and the château. I've got this character (who I later named Rosie), I thought to myself, and if she had an interesting job – such as being a costume designer – it would enable her to flit from place to place and have an interesting life.

'It suddenly dawned on me then that Rosie was a woman living in a château in the Loire Valley, but what were her problems? The main problem, I decided, was that she is in an unhappy marriage. But that was not enough ... Maybe, without knowing it, she is in love with her childhood sweetheart ...'

The possibilities of what could happen to her character are then explored. 'Once I have the main character firmly in my mind and I know his or her problems, I start to think about the other characters, going through a similar process. And then I think about the plot – to me, that means the structure of the novel. 'I ask myself: Am I going to tell the story in the past *or* am I going to start the story in the present and go back to the past (as in *A Woman of Substance, Act of Will,* and *The Women in His Life*)?

'A number of my books have started in the present and gone back to the past – so that I can tell the story in flashback – and have then come slowly back to the present.' However, deciding on which structure to attempt is only taken after a thorough appraisal. 'I analyse their characters, their past life and what it's all about and how it will come together – it's a practical way of thinking. Journalists, for example, have asked

me why I didn't start *A Woman of Substance* when Emma was a little scullery maid at the turn of the century. I thought, wouldn't it be more interesting to the reader to pull him or her in to the story of a rich and powerful woman and make it contemporary by starting it in the present day?'

Weighing up how best to structure your story means making firm decisions, 'But in a way, it's the story itself which dictates the structure and length. If you are writing about sixty-four years of a woman's life, it's going to be a much longer book than if you are focusing on three months of a person's life.'

At this planning stage, there are other factors that Barbara takes into account, one of which is viewpoint. She often writes from the viewpoint of her protagonist but sometimes changes tack to get into the minds of other charcters. In one scene, for example, the narrator switches back and forth between the characters of Emma and Rosie, a kindly barmaid:

> Fully conscious of Rosie's growing interest in her, Emma said, 'With his grandmother. Near Ripon. My husband is an orphan, as I am. His grandmother died recently and now I am alone, since Winston is at sea ...'
>
> 'I see,' said Rosie, nodding. 'and how did yer meet Blackie then?' She was no longer able to control her avid curiosity.
>
> 'Blackie came to do some work for – my husband's grandmother,' Emma improvised swiftly ... 'He thought a well-educated person like me would be useful in a shop. I can sew and do alterations.'
>
> 'Aye, that's an idea,' said Rosie, feeling extremely pleased with herself. She had been right about this girl coming from Quality folk. It had been patently obvious to her all along that Emma could only have met Blackie in his capacity as a workman, doing repairs at her home.

Contrary to the view that it may be more difficult to write in the third person than the first she comments, 'I think third person is easier than first person. In *A Woman of Substance*, I knew that I was going to have a lot of characters, so I needed to be Emma, Blackie, Rosie and Edwina and all those other people.'

But there is an essential ingredient which the author considers before she starts writing and that is research. She is

an inveterate reader and researches every book thoroughly before she has the confidence to write about the subject. It can take many forms. For *A Woman of Substance*, for example, her acknowledgements include thanks to a host of libraries and organizations including the Reading Room of the British Museum, the Newspaper Microfilm Divisions of Leeds Public Library, the Imperial War Museum, and Kirkstall Abbey House Museum, Leeds, to name just a few sources. And even Marks and Spencer's for providing photographs of their original Penny Bazaars in Leeds Market and details about the founding and development of that company. Other research included studying the woollen mills in Yorkshire.

'The novel is a monumental lie,' asserts Barbara. 'You can't be a novelist if you don't have a good imagination, however good a writer you are. The monumental lie must have the absolute ring of truth if it's going to succeed. And that underlying truth comes from research – it makes the novel seem real. You take the characters, you put them in a certain time and place, and add historical events to give a ring of authenticity.'

The Women in His Life confirms her point about research – and that essential 'ring of truth'. Her husband Robert Bradford escaped from the Nazis and this episode features strongly in the novel. Barbara read over thirty books dealing with the tragic history of World War II, beginning with Germany in the 1930s. The titles included *The Past is Myself* by Christabel Bielenberg, *Winston S. Churchill: Vol VI. Finest Hour 1939-1941*, edited by Martin Gilbert, and *The Rise and Fall of the Third Reich* by William L. Shirer.

'I had to make three trips to eastern Germany for *The Women in His Life*, to research the city of Berlin as it was in the early thirties, and other details such as when a particular train left Berlin on a particular day, which I got from the City Museum in Berlin, and daily life in those days.'

Primary research – that is, visiting people, often experts, companies or organizations to get a 'feel' or background information for a novel – may cause beginner writers unease. After all, it's one thing being a published writer asking for help and it's another being an unpublished writer looking for a break, isn't it?

This gets short shrift. Barbara has only one thing to say: 'You will just have to take courage in your hands and do it, right? Right!

But there's one final thing that Barbara always does before she begins writing her novel and that's drawing up an outline, which she doesn't even show to her publishers. 'It's about eight to ten pages and it lets me know where I'm going and helps me sort out my thoughts. I tell the story to myself as I am writing it. I say, "It's going to start here and move to there and it will end there.' It's a sketch of what the book is about, what the characters are about, and what I need to happen in the book to make it work dramatically.'

Then, at last, it's down to the hard slog of writing the novel itself. Barbara, who works from her apartment in Manhattan, is stationed at her desk from as early as 5.45 a.m. and stays in her room all day until six o'clock. 'I am not writing all that time, but thinking, editing, and going over my research, just having a snack for lunch. From summer 1992, I've only been writing five to six days a week instead of seven, as my husband and I have bought a house in Connecticut and spend weekends there. I don't know how I keep my schedule up – I think it goes back to really wanting to do it because of an inner compulsion.

'Every writer has a different method, but I try to write 1,250 words per day. I do not start on page 1 and get to page 500 and say, OK, that's my first draft. I couldn't do it. I think I'd be afraid that I would lose the emotional feelings I had had at the time of writing. Let's take an example from *Angel*. I have to understand that Rosie is going to get irritated with Gavin when he snaps at her about the French family. Now, if I'd got to page 500, I might not have remembered exactly what Rosie's feelings were at that moment because I am living it at the same time.

'I have to write each chapter over and again until I've got it right. It may not be every page – it might be only three pages – and I don't do a chapter a day. I'm lucky if I get between five and eight pages done. Sometimes I'll have five pages finished and three in rough for the next day. Here's a tip for beginner writers: always leave something that you can work on next

morning because it gets you flowing again. I continue like that until the end of the book and then send it off.' The book goes to her literary agent in New York who then deals with the publishers.

Though based in New York, Barbara still finds time to return to Britain, when she visits her home town of Leeds, where she was born in 1933. The only child of a children's nurse and an engineer, she was encouraged to take an interest in books from an early age. Her mother was a voracious reader who introduced her to the delights of the local library, music, theatre and literature.

Barbara started writing children's stories when she was seven, and at twelve sold her first story to a children's magazine, for which she received ten shillings and sixpence. 'When I first saw my name in print, I knew my destiny was sealed. There was no other choice. I had to become a writer.'

After attending Christ Church Elementary School, and Northcote Private School for Girls, she got a job as a typist on the *Yorkshire Evening Post*. After six months she became a cub reporter and helped on the women's page. At eighteen she became women's page editor and two years later moved to *Woman's Own* as their fashion editor. She later progressed to Fleet Street, where she worked on the *London Evening News*, and *Today* magazine and the *London American* newspaper.

At the age of twenty-eight she married Robert Bradford, associate producer on such Hollywood epics as *55 Days in Peking*, starring Charlton Heston. She met him through a mutual friend. 'She asked Bob to call me to tell me that she couldn't come to London because she had broken her ribs. Bob and I started going out and got married about a year later.' Bob now produces the mini-series based on her novels.

Moving to America to be with her new husband, Barbara continued with her career in journalism, writing three columns a week on interior design and lifestyles, which were syndicated in 185 newspapers. She also wrote eight books on interior design. Her first novel *A Woman of Substance*, was published by Doubleday in 1979 in the United States and in 1980 in Britain by Granada Books. This was followed by *Voice of the Heart, Hold the Dream, Act of Will, To Be the Best, The*

Women in His Life, *Remember* and *Angel*.

Barbara Taylor Bradford's tips for beginner writers:

- **Forget about formulas**
 You really have to feel the need, emotionally and psychologically, to sit down and create a story. It must be so compelling that you have to get it out. If you try to invent a formula just to write a best-seller in order to make money, it is not going to work.

- **No drama = no novel**
 I start with the main character and I say, Who is he or she; what is his or her problem? Without a problem, you don't have a drama and without a drama you don't have a novel.

- **Make use of your imagination**
 You can't be a novelist if you don't have an imagination, however good a writer you are. The novel is a monumental lie which must have an absolute ring of truth if it's to succeed.

4

Frederick Forsyth

Frederick Forsyth was born in 1938 and grew up in Ashford, Kent. 'Mother had a dress shop and Dad had a furrier's above it. They worked together in a small provincial town called Ashford. If there were going to be other children, the war intervened and in 1945 my parents thought it was a bit late for them to start over,' he explains. This meant that he was often on his own as a child. 'Most of my contemporaries were evacuated and I wasn't. I spent a lot of my boyhood inventing my own games and devising plots, which may have given rise to what happened later. I don't know. I never thought of being a writer. I knew what I wanted to be from my mid-teens onwards in succession and did them all and the third and last was foreign correspondent. Being a novelist was coincidental.'

A gifted child, he attended Tonbridge School and passed nine O levels aged fourteen and three A levels in English, French and German a year later. His linguistic ability was to stand him in good stead and the vocabulary of modern European languages often appear in his novels. 'I already spoke fluent French by the time I was thirteen and pretty good German by fifteen. My parents sent me abroad during my hols, first to a French family for four consecutive summers and then a German family for three. Living with families which spoke no English taught me the languages.'

Ever keen to get on with life, he said, 'I wanted to leave after A levels but the school got very upset and talked to my father and he said to me, "I understand you want to leave," and I said, "I do." He said, "Well, the school want you to go on to university and try and get a scholarship. You've still got a year and three-quarters to go." I replied, "I don't want to stay on." He said, "I'll do a deal with you. Stay on for the winter term and take the S level in November, win or lose, you can leave in December." And I did.'

Frederick Forsyth left Tonbridge when he had just turned seventeen and joined the air force until he was nineteen and a half, before spending three years as a reporter with the *Eastern Daily Press* in Norfolk. He joined Reuters in October 1961 just after his twenty-third birthday and in May 1962 was posted to Paris, where he joined the resident staff. There he was assigned to follow Charles de Gaulle whenever he left the Elysée Palace in case he was assassinated.

'In October 1963 I was given the one-man Reuters Bureau in East Berlin, covering the then East Germany, Czechoslovakia and Hungary during a fascinating period, at the time of the assassination of Kennedy, tension on the Berlin Wall etc. I returned to Paris in September 1964 and remained there until April 1965, when I returned to London of my own choice. My four years with Reuters had been very eventful, with residential assignments in Paris and East Berlin. Other stories were covered in Prague, Budapest, Leipzig, West Berlin, Brunswick, Hanover, Bonn, Brussels and Rome. In London, I applied for a job with the BBC and joined them in October of the same year.

'I arrived at the BBC as a radio reporter, which meant tape-recorder on shoulder (they were bigger those days, about the size of a typewriter), shoulder strap and microphone, and went round doing street interviews or setting interviews up for the South East Radio News. Then I graduated to Alexandra Palace, which was then the home of television news, and did a stint of about a year, working on a programme called *Town and Around*, which came on at 6.05 p.m. Then when I came back to Broadcasting House in February '67, I worked on *The World at One* and radio newsreel.

'When I was offered the chance to cover the Biafran War I jumped at the chance, even though I had never been to Africa and was a European specialist.' It was to be shortlived, however. 'I spent three months there before being recalled. The Foreign Office only wished the war to be covered from one side, that of Lagos. I was shunted down to Parliament as a way of keeping me quiet, and resigned in February 1968 to return to Biafra as a freelance, fed up with what I regarded as news management.'

What he saw disturbed him into writing a non-fiction book, *The Biafra Story*, in the summer of 1969, sitting in a caravan in the middle of the bush. 'I covered Biafra between '67 and '70, a horrendous war between the eastern region of Nigeria, self-styled Biafra, and the rest of Nigeria. I wrote it as an accusation, a sort of *J'accuse*, against the role of the British Government, international cynicism and hypocrisy that was behind it. It was basically an oil war and the West's lust for oil. It had nothing to do with freedom or democracy – imperial claptrap – and the kids just got in the way.'

Thousands of starving people haunted world television screens. How did he cope with seeing starvation in the cold light of day? 'One became inured to it – eventually. It took time. I remembered fairly hardened seasoned reporters from Fleet Street coming over for a week and being absolutely shattered. Gutted. It was hard to stay sane.'

Frederick Forsyth went back to Britain to get his typescript published, before returning to Biafra in autumn 1969. But it was to be a brief visit. The country collapsed and was invaded by Nigeria and he got the second-to-last plane out. Flying back to London on Christmas Eve 1969, he celebrated Christmas and New Year, and on 1 January 1970, aged thirty-one, he sat down and started to write *The Day of the Jackal*.

'Being unemployed is a great incentive. I hadn't got any commissions, I hadn't got a flat and was staying with friends and had time on my hands. They went out to work and I was mooning around all day so I thought I would try and make some money.

'I wrote 4,000 words a day (which is about twelve A4

pages), seven days a week. When I finished the manuscript it was about 450 pages – about 120,000 words. It was written on a typewriter, journalist-style with two forefingers. I don't like writing in longhand; its hardly legible.'

When Frederick Forsyth began writing he knew nothing about editing or publishing the book, or what it would be worth, if anything. But what he did know was the story. 'I'd had this idea in my head since 1963 when I was on the staff of the Paris Bureau for Reuters, covering a wide range of daily-breaking news stories, particularly the attempts to assassinate Charles de Gaulle. My work included reporting on the activities of the OAS (Secret Army Association, a fanatical group sworn to kill de Gaulle) and it occurred to me that they were failing to kill him because they were, broadly speaking, all tagged by the counter-intelligence people.

'Their names, identities and movements were known. Photographs were plastered everywhere on wanted posters. They spent so much time trying to stay out of the clutches of the intelligence people that they hadn't got much time left over to try to kill de Gaulle. They had a few attempts but they all failed. I thought, Why don't they use a professional, an unknown face, someone who isn't on file?

'Out of that rather basic idea came the notion of hiring a contract killer. I then went off on other work in East and West Berlin, Prague, Budapest, Rome, Brussels, Bonn and Palermo, but the idea ticked over in my head, getting a little bit expanded. A little more of this, cut this out, change this, turn this around. I worked on it as a mental exercise, never thinking I'd ever write it. It was just an idea. But in the winter of '69 I decided I had to do something, so I began to polish the story in my head.

'When I finally sat down and started to write it in January 1970 I did so virtually without reference to research work or anything else, because I'd rehearsed it long enough in my head to know what I was doing. I knew Paris intimately; I knew France; I did some checking with some rather unsavoury characters of my acquaintance about illegal guns, illegal passports and the business of killing people, which provided the technical detail that everyone talks about.

'When they made a film of my novel, they made the gun to the specifications in the book. They showed a gun-maker the passages and said, "Can you make that?" and he said "Yes, it's feasible. At least I think it is." And he produced the gun which Edward Fox used in the film and it worked. They made two models. One which was designed not to work and one which fired. The one which was fired by Edward Fox was used in the clip in the film where the Jackal blows the melon apart hanging in a bag, swinging from the branch of a tree. The gun actually did break down into tubes, as I'd described in the book and it could fit inside a crutch.'

In order to evade the police the Jackal assassin dons several disguises. Frederick Forsyth comments, 'If he had simply slipped into France and shot de Gaulle there would have been no particular tension so there had to be tension – reasons for the upsets. I hit upon the idea that the French Intelligence Services would get an inkling that there was an assassin in existence but they didn't know his name. From this came the idea of capturing the bodyguard of the OAS chiefs and torturing him until he blurted out that the OAS had interviewed a blond foreigner called the Jackal. In the novel, a leak within the Elysée Palace enabled the Jackal to be fed warnings, allowing him to evade the police.

'The point about a novel of tension is that there must be twists and turns so that one minute you think one guy's on top and then you discover the other guy's escaped and he's on top and then he has a set-back and so on.'

What elements make a thriller? 'There are certain inalienables. Broadly speaking, there is a central plotline which is about a project of some kind. It may be an outrage, where the bad guys are going to try and do something appalling and the hero's job is to try and stop them or maybe it's the other way round. The hero has to go into a situation to do something and the enemy is going to try and stop them. If you look at just about any thriller, that in essence is what it is about. There are always at least two sides – sometimes more than two – but there must always be opposition. One opposing the other.

'You are supposed to sympathize with one guy – the hero –

he may be an anti-hero but you're still supposed to sympathize with him – and the dramatic conflict stems from the opposition of these two sides. Kipling referred to espionage as "the great game" and in the days of the Cold War there it was used over and again by John Le Carré and Len Deighton. It was the opposition between the Western Alliance and the Soviet Union. The Soviet Union was usually represented by the KGB and the Western Alliance by British or American Intelligence and that was the basis of the spy thriller.

'If there was no opposition, there could be no tension. If your hero was told, "Fotheringay, you're the best man we have. I want you to go in there and steal this ring and bring it back," and he went in and all the doors were open and he stole what was wanted and brought it back, it would be over by page 50. There has to be somebody trying to stop him doing it.

'Mixing in real characters with fictional ones has become quite fashionable but it started with the Jackal and it was inadvertent. It seemed to me that if I was going to write a story about France and its President in 1963 it would be utterly foolish to call him President Dupont because everyone would know his name was Charles de Gaulle. So I thought, he's there, it's a matter of history that the OAS did try to assassinate him, so we'll call the OAS the OAS and Charles de Gaulle Charles de Gaulle.

'From that point on, I thought to myself, if you're going to call the President by his real name, why not call the Interior Minister and the Chief of Police by their real names, so a whole raft of French characters appeared who occupied those positions at that time. None of them objected later to appearing as a character who said certain things which they didn't say. It didn't seem to worry them, in fact they were quite amused by it.'

After thirty-five days, Frederick Forsyth's first and final draft of the novel required little editing. He took it to a part-time literary agent, but they had to part company. 'I felt that the part-time agent needed to earn his living by his various other projects, and could not give (so I believed) the placing of *The Day of the Jackal* the single-mindedness that I wanted it to have. In the early days it went to four consecutive

publishers and they all turned it down." Which ones were they? Frederick Forsyth declined to answer. 'No names. The guys who did are still pointed out at cocktail parties as "He's the guy who turned down *The Day of the Jackal*" or "He's the guy who said Michelangelo couldn't paint." It's not an easy job, so we don't have to dance on their graves.'

After the four rejections, he still felt that although his book might not be particularly successful, it was worth publishing. 'At airports I'd often grabbed books off the shelf for a flight and closed them in utter disgust after fifty pages. Some were complete and utter rubbish, totally inaccurate, grossly inauthentic, hardly made sense and the plotline was ridiculous. But why were they being published and I wasn't?

'I thought that what I had written was comparable, if not necessarily better. I came to the view that the publishers' readers were only getting through perhaps the first half of the first chapter. I admit my books start slowly without blistering action. There is a slow placing of the pieces on the chessboard, which means it can take up thirty, forty, fifty pages before things really begin to roll. The reason I do this is so that when the action begins I don't have to go back and say, "By the way, this is Smith. You don't know anything about Smith so I'll tell you about Smith," because it holds up the action. I tend to introduce Smith at the beginning and then put him on one side, like a chess piece. He's there, he's ready, he's waiting and eventually he will come into the action.

'It seemed to me, therefore, that the readers might think my first thirty pages were slow. These dealt mainly with the execution of Jean-Marie Bastien Thiry, who was the mastermind of the plot and leader of the team. He and one other were sentenced to death, but the sentence on the other man was commuted to life imprisonment. Only Bastien Thiry was executed; of the rest, some got life; the others, long terms of imprisonment but less than life. In a series of amnesties, they were all freed in less than twenty years.

'If they found these pages slow, I thought, it could be that they weren't getting any further. They were discarding the book because it was an attempt to kill Charles de Gaulle and as he was still alive at the time, they must have wondered what

the point was because they knew the plot would fail. So I wrote a synopsis of twenty pages – the book in microcosm – and took it in person to Mr Harold Harris, who was literary director of Hutchinson's at that time. He read the synopsis in front of me while I waited, and then asked for the full manuscript. He read it from Friday to Monday and on the Monday said, "I'll sign you up."

'It's unusual for manuscript number one to hit the jackpot. I was lucky it was the right time, right place and right editor. Harold was a wonderful guy who died in October 1993. One hears of people who've had fifteen, twenty, thirty rejection slips and finally put it away in a drawer to get on with manuscript number two. Most, I think, have a commercial success with their number three or number four. Once they've done that, they can then reissue rejected manuscripts number one, two and three.'

After *The Day of the Jackal* came *The Odessa File*, followed by *The Dogs of War*, *The Devil's Alternative*, *The Fourth Protocol*, *The Deceiver* and *The Negotiator*. He's edited a book of flying stories and has also written a collection of short stories, *No Comebacks*. So what preparation does he do before he begins writing?

'I think about the novel for a year. During that time I don't write at all, not even make notes. If it's mental, it's more flexible, I can pull characters in, out, turn them around, make them do different things, drop an idea or try another one, make variations. If I start writing things down, they become concrete. I retain everything in my head, rather like playing mental chess and seeing how many moves it's going to take.'

Meticulous research is a hallmark of Frederick Forsyth's work. Is he willing to give some examples of how he researches? 'In broad terms, yes. I devise the story first and then identify various areas of which I know nothing. It may be isotope separation for nuclear physics, the workings of an American jet fighter or the Israeli Mossad. What I normally try and do is try and find an expert. I don't spend an awful lot of time on books. People say, "You must have read fifty or sixty books to find this out." The answer is no. If I did that it would take me years to study it. It's easier to find the writer of the textbook.

'If I want to know about nuclear physics, rather than read vast tomes which would blow my mind, I'll find a professor of nuclear physics and say, "Look, never mind six hundred pages, I've got one question: would it be possible to do this, this and this? and if so, how?" Usually by the end of two hours I have got that section sorted.

'I then have to put it into what I call layman's language as professors of nuclear physics tend to talk like professors of nuclear physics. I say something like: This is why ... This is how an atom bomb actually works. This is what happens ... When that mass and that mass are crushed into each other and go critical, there's a blizzard of neutrons which start the chain reaction and you get your explosion.

'If. however, I am talking about a particular scene which takes place in Brussels, Amsterdam or Paris or a village in the Dordogne, rather than a piece of technology, I go to that village or restaurant or railway station. Very rarely do I put a scene in that I didn't visit. When I say there are five steps leading up to a restaurant there are exactly five steps. If I say it's 150 yards to that corner of Revolution Square in Moscow and you take a right and there's the Defence Ministry in front of you, the reader can follow it, use it as a guidebook.

'You might be thinking, Well why bother with such detail? Why not just say he pulled a gun and fired? Why do you have to say which gun, where he got it from, what sort of ammunition he used? I suppose the answer is that it may be very pedantic, but the readers like to be told little bits of inside information such as: "For many years the SAS favoured the Browning 13-shot 9mm automatic but two years ago they switched to the rather more powerful and more reliable Swiss SigSauer," which is true. You will still get other writers saying the SAS carry the Browning 9mm but they don't. Insisting on finding out the standard handgun of the SAS means research. You have to put yourself out. It's rewarding to know that one has got it right. Even down to the type of gun used.'

But it's quite daunting, isn't it, if you're an ordinary person and want to approach an expert, saying you'd like to write a novel and you don't know if it will ever get published or not,

but could he or she help? Frederick Forsyth agrees. 'It is harder when you are just beginning. When I wrote *The Day of the Jackal*, I fortunately didn't need to do a lot of knocking on doors because the story was retroactive. I'd been there in '63. I knew, because I'd been following de Gaulle as a reporter, who the characters were, I knew what the Action Service was, I knew what the French SDECE (counter espionage/internal security) was. I knew where they were and how they operated. I could write most of it. I didn't need much "official" help.

'By the time I got to novel number two, *The Odessa File*, I got a lot of help from an obvious source – Simon Wiesenthal.' Had he actually met him as described so clearly in the book? 'Yes, that's Simon, the way he was. In a sense I put myself in the steps of Peter Miller – or put Peter Miller in my steps. Everything that happened to him happened to me. All the shut doors, the glazed eyes: "I am sorry, Herr Forsyth, I cannot help you."

'By novel number three, when I wanted to talk to a senior civil servant, scientist or general, the doors were beginning to open. "Ah, you mean *that* Mr Forsyth. Lunch? I would be happy to join you for lunch, Mr Forsyth." And so it began to happen that they were prepared to talk to me, knowing what I wanted to talk about. I have found that the great majority of experts actually like talking about their expertise. Many of them feel they are under-valued and under-appreciated. They are masters of their area and they love talking about it.'

Frederick Forsyth puts 'what-if' scenarios to them. He asks them, for example, 'If this crisis occurred, how would you handle it? What would you do? ... They become quite intrigued themselves and either say, "I hadn't thought of that," or they say, "As a matter of fact, we've been practising that contingency for a number of years and we've got it all worked out."

'In *The Negotiator*, for example, I posited the idea that the son of the president of the USA is a Rhodes scholar. This is not quite so crazy if you take the fact that Bill Clinton was a Rhodes scholar at Oxford and John Kennedy Jr. did some time over here at university, although his father was already dead. Put the two together and it's not so weird that the

twenty-year-old son of the president should be a Rhodes scholar. It would pose the question of what would happen if he was kidnapped. So I went to the Thames Valley Police and they said, "Oh my God, a nightmare scenario," and I said, "What would you do if it happened?" They told me. "You say that in the squad car we had following him, three officers have been shot? One Special Branch and two of our own people? Wow! Oh God!! We'd follow the book."

'Whenever there's a crisis, all people in a position of seniority – civil servants or police officers – say to themselves: "As you're going to be criticized in a court of inquiry anyway, follow the book to the letter. Don't try any brilliant initiatives; they will probably go wrong and you'll be blamed." They told me that the chief constable would have to ring London and tell the Home Secretary.

'I hared up to London and asked a senior civil servant for the Home Secretary what would happen if this call had come through. "Oh God, a bloody disaster," he said. "But who would tell Mrs Thatcher?" I asked. "The Home Secretary would. Nobody else would dare." "And what would she do?" "She would summon the Home Secretary and his permanent under-secretary a bit sharpish round to her office at 10 Downing Street and would ring the president. She wouldn't give the job to anyone else," said the civil servant. You only really get inside guff like this from people who live in that world.' Quite so.

Frederick Forsyth explained how he took the research even further. In *The Negotiator* the president's son is blown up by a bomb and he wanted to find out what would happen next. 'I spoke to the UK's top forensic pathologist, Dr Ian West, who discovered Julie Ward in Kenya had not been eaten by lions when her bones were discovered in a campfire. I had lunch with him and I asked, "If you had a body blown apart by a bomb, can you run me through the autopsy?" And he did. They take out the central section of the body and reduce it to an enzyme soup, spinning it in a machine to get out the fragments of metal.'

Does he use a tape-recorder for these interviews? 'No, occasionally I use a notepad and scribble a very technical term

which I won't be able to recall or a name, date or place, but I can remember the basics of what's done and how it's done. I may retire later after lunch and then scribble it down, covering three or four pages of notes. Some people don't like a tape spinning or notebook scribbling; they dry up or become inhibited. This way it's just two guys, one lunch table. Once the wine's finished, a glass of port, a nice cup of coffee, then: "Have a cigar?" "Thanks, now what do you do?" And they talk, broadly speaking. Occasionally I get, "I am sorry, I am not prepared to discuss this subject." But if I don't get it from him I'll get it from somebody else.'

Does he also read books that deal with the subject at hand? 'Yes, with *Fist of God* I read about twelve books, which was an unusually large number. But as it was a real war in which people got killed I had to be pretty accurate. So I read Sir Peter de la Billiere's memoirs, Norman Schwarzkopf's memoirs and seven or eight books, some to do with the war and some with other subjects that cropped up. These books included *The Republic of Fear*, which dealt with the Iraqi regime of Saddam Hussein. I needed real placenames and events, so that I could say a particular event had happened and that a bombing raid was carried out by the exact squadron. I tend to buy the books I need rather than to go to libraries, however.'

Throughout his novels he mixes real and fictional characters, so how do these people react when they see themselves and their trade immortalized in print? 'Usually no problem. When I see guys in the business, they talk, laugh, tell me they've read such and such a novel and loved it. Sometimes they even have a giggle because they know a character is drawn from life – one of their colleagues, ex-colleagues or opponents.

'I have been told on several occasions from pretty reliable sources that the KGB, when it existed, liked my novels. It used to send a limousine from the Embassy to Hatchard's and buy fifty of whatever came out and fly them in crates in the diplomatic bag to Moscow to be distributed among senior English-reading higher-ups. They ran off translations pretty quickly for those who didn't read English and they were

passed around the top boys in the KGB. And they enjoyed them. Sometimes they recognized themselves and other times the Brits and the CIA men. The characters were all reasonably lifelike, so they could play spot the mate or spot the opposition.

'In *The Odessa File*, I used real Israelis and real Germans, real Nazis, and in *The Dogs of War* I used real mercenaries. Normally the real characters play a small part such as statesmen, ministers, senior police officers or spy chiefs. These real people, he asserts, can't say, "You've libelled me." All they could say if they wanted to be really picky is: "You had me saying things I never said,' to which I don't think a libel court would pay much attention. They would say, "Were you offended by it?" and if they said, "No," there would be no libel. You can only be sued for libel if you bring an individual into hatred, ridicule or contempt in the eyes of an ordinary person. So if you don't do these things and write, for example, about Margaret Thatcher presiding over a Cabinet meeting in a perfectly responsible manner, there's no libel.'

It's difficult, though, isn't it, for first-time authors to use people known to them? 'Well, yes,' Frederick Forsyth concedes. Suppose, for example, they are considering writing about their neighbours? His advice is as follows: 'Normally the people I choose are very public figures. Senior politicians and the like are accustomed to being caricatured, lampooned, criticized and abused. It's a tough profession. If you can't take the heat, as the former president said, get out of the kitchen. So if they've gone through a long political career, they are not going to be too upset about me putting them in a book. But if you write about a next-door neighbour, a quiet little chap living a perfectly quiet life and suddenly he appears under his real name doing things he never did, he would probably get upset. It's a question of whether the person is important enough. If I used the head of the KGB, I hardly think he's going to bother to come over here and go to the High Court and say, "You said very naughty things about me in that book," because the answer is that if you spend your life doing very naughty things ...'

Frederick Forsyth's books cover assassination, spying,

terrorism, blackmail, murder and mercenaries. 'Why do people want to read a thriller?' he asks. 'Presumably, the "taste" for reading a thriller as opposed to the novel about the next-door neighbour is that readers want to be taken out of their world and into someone else's which they hope is not a fantasy. Otherwise they'd read Stephen King. *The Fourth Protocol* and *The Deceiver*, for example, were set right in the heart of the spy world ... I try to get everything as accurate as I possibly can.'

Writing from the viewpoint of the omniscient narrator enables Frederick Forsyth to tell the reader about the activities of all the characters. He comments, 'I've never done a first-person narrative. If I say, "I am Smith and I do this and I do that and I came in and sat down," I couldn't know what's going on round the corner. I like to take the reader backstage, in one analogy, and, using another analogy, to the mountain top. I want the reader to be able to look down on the plain and observe all the characters. They can't see each other. He's moving behind that bush, he's behind that mountain and he's across the river.

'*We* can see them all – it's not just the author saying, "I am on the mountain top," I try and bring the reader to the summit. The only things I continue to hide are events which will happen in the future that only I know about. But then I'm a storyteller, so I'm allowed to.'

The novel is a genre within fiction writing that contains numerous sub-categories – horror, supernatural, romance, historical. 'The thriller is only one such category. Within the thriller there are basically four smaller categories – crime thriller, political thriller, spy thriller and adventure thriller (*Indiana Jones* etc.). The only two I have ever attempted are political and spy thrillers.'

He has a clear idea of what he needs to do in his novel. 'I try and take the reader, metaphorically speaking, by the hand backstage, because much of life, as I see it, is rather like a play. Everybody we see is prepared, they're in make-up, they've got prepared words. What you see is not what they are. To continue the theatrical analogy, I take you back to the dressing-rooms where you see them stripped off, with no

make-up, grease-paint, wigs ... And I show you how the special effects are done, how the thunder and lightning is produced, how the guns are made, where they come from and how the explosives are detonated, and so on.'

His technique of taking real-life events as a backdrop and painting on the backdrop with real and imagined characters can be seen in *Fist of God*. '*Fist of God*, published in April '94, has probably got more characters in than any of my previous books. It's a huge canvas called the Gulf War with an enormous range of real characters – Margaret Thatcher, John Major, George Bush, American secretary of state James Baker, Norman Schwarzkopf, Sir Peter de la Billiere, General Glosson and General Horner, [the two American air force generals who planned the air war], Saddam Hussein and his Cabinet. And painted up against them are the fictional characters. Let's make another analogy: It's a huge mural which we know happened: the men, tanks, guns, commanders, generals, politicians, diplomats, aeroplanes, ships. What I do is paint on a few characters who weren't there. But as the characters who weren't there seem to be addressing the characters who were there, the notion is that the reader is not entirely certain whether this man did or did not exist and whether what he did did or did not happen, and that is the intention.'

Does he make notes about his characters before he starts writing about them? 'I jot notes down, otherwise I would never remember them, particularly the fictional ones. I always sketch out the main characters' backgrounds – where they came from, how they started, why they got to that job. In my novels, a main character will usually be prefaced by a page or so of background introduction. It's a descriptive passage so that when we see him next we remember who he was: "Oh yes, he's the guy who does so-and-so; he's tall, thin, angular, tends to wear tweeds – or he's short and tubby with freckles and ginger hair." That sort of thing.'

Perhaps one of the strengths of Frederick Forsyth's characters is that however professional or ruthless they are, there is always a hint of the person underneath the outer shell – certain events are shown to have shaped how the character

behaves and how we see him or her. In *The Day of the Jackal*, for example, there are a few lines where the narrator comments that the Jackal is now wearing the clothes and driving the sports car of the person he had wanted to become three years earlier. It engages the reader's interest because it suggests that this alien creature may share some of their own preoccupations or those of people they know.

By describing the Jackal as wearing the clothes and driving the car of the person he wanted to become, Frederick Forsyth allows his readers a glimpse of the inner thoughts of the man, which otherwise remains hidden throughout the novel. The author was surprised, however, by the extent that readers told him they were rooting for the Jackal. He reminds us: 'He was doing a job for half a million dollars (it would have been five or six times that figure today), which would make him wealthy for life. He had had a glimpse of that life but when he was almost inside France he had been warned that his cover had been blown. He had the choice of going back to Italy and calling it off or going on to Paris. He thought of the life he wanted to live and decided to risk it and go on, knowing that his cover was blown and he could get killed. But he was prepared to go on – that was his lust for money – he was a pure professional.'

So is it essential that the reader can identify with the main character? 'Not identify but, perhaps, empathize. There are novels where people are invited to identify with a sympathetic principal character, but there are novelists, such as Simon Raven, who write novels where the principal character is an absolute bastard and nobody really wants to identify with him. There have been a rash of novels recently where the principal character is a total wimp, deeply unrespectable or unable to be respected and everything happens to him rather than the other way round.'

The Odessa File details the struggle of a young German, Peter Miller, to expose a secret society providing new identities for Nazis in post-war Germany. In the process Miller tracks down one of its most notorious war criminals, Roschmann. It's a good example of Frederick Forsyth making us think we know the main character and suddenly we

discover we don't. He manipulates the reader into accepting Miller's motives at face value. At the end of the novel, Miller admits that the reason he has been so keen on tracking down Roschmann and the Odessa File members was because Roschmann killed his father.

'You thought he was triggered by a wave of sympathy for the plight of the Jews in Riga? Yes, that was the irony. My idea. That's what you are supposed to think until the end. There is a passage in the diary of Salomon Tauber which is true and the events actually happened. It was narrated to me by someone who was actually there at the time. The Nazi Roschmann did shoot and kill a German officer on the docks at Riga. When I heard that anecdote, it became the trigger for Miller.

'When he read Salomon Tauber's diary, detailing the horrors of Riga, Miller was outraged, horrified: he'd never been told these things. They'd been hushed up in Germany in the fifties and sixties and the young people were not told about them.' Although Salomon Tauber and his diary are fictional, every single incident alluding to Roschmann actually happened. There were eye-witnesses to everything claimed by the diary. Salomon Tauber is really an amalgam of those six or seven witnesses.

Today Frederick Forsyth says, 'There is a new generation who are finding out about the war by their own insistence but in the immediate aftermath the generations of the fifties and early sixties were not told what happened. In the novel, this was Miller's first exposure to the records and he was obviously shocked by it.'

After *The Odessa File* Frederick Forsyth reverted to using a 'hard man' as his main character, again allowing the reader to see a glimpse of the human compassion beneath the professional. In *The Negotiator*, for example, years of soldiering as a Green Beret made the protagonist, Quinn, into a hardened negotiator who is prepared to kill, if necessary. But seeing a little girl die in Sicily causes him to resign in disgust and retire.

The author agrees that this hint of compassion allows his readers to empathize with some of his more hard-bitten

characters. 'The traditional hero is the guy who makes things happen,' he says, 'but I don't think people particularly identify with a man like Quinn in *The Negotiator*. It would be very difficult as he's a very, very tough bastard and an ex-Green Beret. Readers like to be taken out of their lives as a bank clerk or an insurance underwriter or whatever to follow a guy like Quinn, with battle scars, who's killed several people and is prepared to do so again. But I don't think many would say, "Gosh, I'm so like him." '

Frederick Forsyth is fond of tantalizing the reader to ensure the pages keep turning. Often the characters are privy to knowledge that the reader is not. The narrator tells us something like, 'They quickly told him what the plan was ...' but the reader is left in the dark until the plot unravels. 'The notion of a thriller is tension. It shouldn't be called a thriller if it doesn't thrill. The notion of tension is a sense of impending doom or a sense of impending unease. I hope to have the reader saying, "To find out what happens next I'll have to turn the page." If he or she stops turning the pages and says, "This is a load of rubbish," I've failed. When readers like a book and say it's a real page-turner or unputdownable, they were so curious to find out what is going to happen, what this bastard knows that they don't know, that they will keep turning the pages.

'The question of revelation, however, is fairly tricky because the novelist has to drop little hints throughout the novel. If I say to the reader, "I'm not going to tell you a damn thing until the last page," and it all comes in an awful rush – he did this, they did that but he didn't know that – the reader's going to wonder why he or she waded through 500 pages of suet for two pages of information. Down the line I drop chunks of information, hints of what's going to happen, which triggers something else.' The need constantly to intrigue the reader is on Frederick Forsyth's mind as he writes. 'I try to give the reader a twist in the tail, so the "true" truth is usually not revealed until the last couple of pages.'

Fortunately, writer's block, which can paralyse writers struggling with complicated plotlines (among others) does not affect this novelist. 'I don't think you can get it if you know

exactly what you are going to do. If you've prepared well enough, it's like a choreographed dance, the next step must follow. If you're wondering what to do, searching for inspiration, you will get writer's block when it doesn't come. Minds are much more mechanical. I don't sit there thinking, Oh, what can I write about? I know what I'm writing about.'

Frederick Forsyth writes between 7 a.m. and early afternoon in a converted barn close to his farmhouse in Hertfordshire, where he lives with his girlfriend Sandy. He has two sons. It takes between forty-five and forty-nine days, working seven days a week, for him to write a novel. 'I still use a typewriter. It took me ten years to move from a manual typewriter to an electric one. I never graduated to a word processor.'

But as with his first novel, he still produces one draft ... What does it look like when he sends it in to the publishing company? 'Very neat. It's typed. I tend to type from 7 a.m. to 1 p.m. maybe 12 noon, and then I have lunch, edit that day's twelve A4 pages and go for a walk. I type about thirty lines per page and about eleven words per line average. Obviously some dialogue is only a tiny half-sentence such as: " 'So what,' he said." But broadly speaking it comes out at 330 words per page, about three pages per thousand, so 4,000 words a day. It's a formula I've stuck with and gets me through the book in about 45 days.'

Frederick Forsyth looks for errors when he edits his work in the afternoons, 'I Tippex them and type in the corrections over the Tippex. I rarely strike out whole paragraphs but if I do I paste a piece of white paper across the offending paragraph, photocopy it and type in the substitute paragraph in the gap. What reaches the publishers is fairly neat; it's vanity. Not many mistakes, not many handscrawled corrections.'

He's exhausted when in writing mode and wonders how other authors manage to be more prolific. 'I couldn't do what Jeffrey Archer does and write sixteen or seventeen drafts. Other people write a page a day for a year. Very laborious. Harry Patterson turns out one or two novels a year. I manage one every three years as does John Le Carré. I just couldn't turn out a book a year.

'By the time I get back from my walk it's about 6 p.m. and I am shattered. I don't want to know. I sit or slump and watch the

television or do the *Telegraph* crossword until about 10 p.m. If you asked me later on what I'd watched I wouldn't have the faintest idea; it's just moving wallpaper as I'm already working on tomorrow even to the point of casting the places, where a character will appear, and how this will all shape up. By the time I go to bed my head's full of all this. I sleep through the night on it and set my alarm for 5 a.m. and I'm in the office for 6.30 or 7 a.m.'

The punishing month-and-a-half schedule eventually comes to an end. 'When it's finished it's like being released from school on the last day of term. It's a great relief when I type the last chapter. There's nothing more I can do. The only precaution I take is that at the end of every day I copy it so I have two copies of the manuscript. I then consign the physically typed original to a vault. One day it will be inherited by my sons and, who knows, maybe auctioned off. The copy becomes the master and I run off five or six copies of that.'

But this is not really the end of the story. His work still has to be edited. How did the editors react to his earlier books and how are his books edited today? 'With *The Day of the Jackal* Hutchinson requested minor changes. They only wanted the first chapter to be changed. It was about twenty-five pages about the execution of Bastien Thiry. They wanted it cut to seventeen pages. The French, however, said they would take it intact as it was an episode of their history – everyone else took the English version.

'I over-wrote *The Odessa File* and the publishing company asked me to cut 20,000 words. I'd done so much research and some of it was so fascinating. I'd written bizarre side-bar pieces which I'd thrown in because they were extraordinary stories about the Nazis and what happened. But they said to me, 'Wonderful anecdotes, but not for this story; it slows down the pace." In *The Dogs of War*, however, I don't think they changed anything, but I cut about 5,000 words from *The Devil's Alternative*.

'Broadly speaking, what happens nowadays is that the original first-draft manuscript is sent to Bantam Press at Transworld and there is a period when everybody in the top

echelons of the publishing house reads it. We then have a round-table conference and they produce their ideas. Out of this synthesis, one of them might say, "This passage isn't very clear; could you clarify it please?" or "This is a mite too long; could you cut it down a bit?" or "This really is so fascinating that it could do with an expansion." In general the alteration of the text, from first draft to what the reader gets, is about 2 to 3 per cent. It's not a rewrite; it's constructive editing.'

How does he feel about editors' interventions? 'Usually they are right. There's no question about it. In the editing process, the editor usually comes up with about 200 queries – an average of one per three pages. Sometimes I can explain why I said it that way and then the matter is dropped. Other times it's clear that I haven't explained it well enough for the layman to understand and it needs to be clarified or I've quite simply got it wrong. Then it's a case of: "Yes, you're right, I'm wrong. It wasn't 1975 it was 1976." Other queries are just straight typing errors.

'Of these 200 queries, about fifty to sixty changes are generated, so I work with the senior editors, both the Americans and the Brits. The American editor comes over and we sit in a conclave and work together with stenographers present to cope with the changes. In about five working days it's done. The novel then goes to the printers. No more changes.'

Does he read his own proofs before the book is finally published? 'I'm supposed to ...' He giggles.

Does he have an agent? 'Very much so. When I got involved with the second book I realized I needed a professional top-line agent and agents are a bit like a Catch-22. When you are unpublished and unknown, you can't get one. By the time you're established, and if publishers are falling over themselves, you don't really need one. Well that's not quite true – you need one, not to sell the work but to get you a better deal. Agents love an author when the only real question is not whether the publisher is going to accept them but how much they'll pay, because then they're just into a straight money negotiation. Simply working out the deal for a famous author is wonderful, delightful and 10 per cent for them.

'The real chore for an agent is trying to sell a new writer. "I wish you'd read this, Harry, because I've got this new young writer, who's absolutely brill. I know we've known each other for years, Harry, but would you read this?" ... It's a hard slog.'

So how would he advise a new writer to find an agent? 'There isn't really any way. It's sheer tenacity. If you send in a query letter to a publisher and get an encouraging reply – "Send you're work in and we'll be happy to have a look at it," – you can then go to an agent. But if you go to an agent and say, "I don't know you and you don't know me, nobody's ever heard of me but I think I can write," the agent's eyes will glaze over because the top agents get twenty a day like that. They just can't help.'

New writers should keep a sense of perspective, however. 'Nobody knows how many *Cruel Sea*s or *The Day of the Jackal*s are turned down every week. But when a blistering new find blockbuster arrives every year, everyone wants to know where the author comes from. John Grisham's the latest in the States, a small-town Louisiana lawyer who scribbled a story down between court cases and is now a multi-millionaire. He made his breakthrough with his second novel, *The Firm*; it was hugely well reviewed, but only then did his first book, *Time to Kill*, really take off. Obviously he's a major new talent. There's even a film with Tom Cruise starring in it.

'But behind that story, however, is another one. They don't tell us how many times that writer was turned down or the number of manuscripts he had written. The only comparison is trying to get your break in acting. It's the same thing – endless auditions – except for writers it's submitting your manuscript rather than giving a performance in front of two people in a darkened theatre. There's the endless, "Don't call us, we'll call you." But eventually, they are all calling – agents, producers, casting directors ..."

Does he enjoy writing? 'No. I think of all the colleagues that I've met – about a dozen – I'm probably the only one who isn't a compulsive writer. The others, broadly speaking, are. Harry Patterson [Jack Higgins] is absolutely at his happiest at his desk with his typewriter. I'm at my least happy. I would

rather be fishing, gardening, tending the farm, doing anything else. I actually don't like writing and therefore find it grossly unjust that I should be successful at it.

'I enjoy inventing a story and I enjoy the research because that is like investigative reporting, which I used to enjoy when I did it. But just hitting typewriter keys day after day, is (a) exhausting and (b) extremely boring and I don't like it. I wish I could get to the end of the research and snap my fingers and there's a 600-page manuscript.'

Has he ever tried dictating a novel? 'I tried once. I bought a tape-recorder and tried to dictate into it but it was absolutely useless. Within a page I had forgotten where I was; I had lost my thread; I couldn't recall what I'd said three paragraphs further up because there was nothing to look at. So it doesn't work for me. I have to physically see the white paper rolling off the roller and be able by looking upwards on the page to check the first, second and third paragraphs on the page, so I don't use the same adjective twice, I don't use the same adverb twice, I don't make the same point that he was blond, twice. If I am talking to a dictating machine I can't remember whether I said he was blond or not, so I'm likely to say it twice.'

Can he picture a time when he won't be writing? 'Oh yes. I'm in a two-novel contract now, of which *Fist of God* is the first. I have to deliver a second in the summer of '96 and I think I'll probably pack it in after then.' So he won't be carrying on until he's eighty? 'No chance. I'll make enough for my old age and enjoy the old age. I don't want to be banging typewriter keys all my life.'

Frederick Forsyth's tips for beginner writers:

- Write about what you know personally, limited though it may be.
- Get your facts right.
- Try and write a story with a beginning, a middle and an end.

5

James
Herbert

'When I've delivered a manuscript, I'm in a high state of nerves, waiting for the phone to ring. I always deliver my work in person to the publishing chairman, who is the first person to read the book, followed by my editor.' So says James Herbert, king of horror writing. 'Usually they rave, but I read between the lines so that I can judge their enthusiasm and find out whether they really think it's good, mediocre, or terrible. I question them about whether they liked a certain scene or what they thought of the premise of the story so that I can really gauge their reactions and see if they maintain their positions. If they didn't like something, they would ask me whether I would consider making changes. But I have to say that it's never happened to me. Most authors are acute and aware and are their own best editors.'

But it's not just the reaction of the editorial staff that James Herbert takes into account. 'I count the calls from the number of people who are not connected with the editorial of the book, such as the marketing manager or sales manager, and judge their enthusiasm. If they ring you, you know you are on to a good thing. If they don't, they didn't like the book.'

Despite countless successes over the years James Herbert cares as much about the novel he's just finished (in this case *The Ghosts of Sleath*) as he did his first, *The Rats* (1974), which

made his name. 'When I delivered my latest novel, the editor grabbed it as soon as I left the building, and started reading at 6 p.m. that evening, missing all the World Cup matches, and was wildly enthusiastic.'

The editor goes through the typescript looking for repetition, bad grammar, spelling and typing errors, and then spends a day with James Herbert in his house in the south of England discussing these and any other points. 'He might say to me something like, "Do you need this paragraph here when you've already said something similar in Chapter Two?", but he never changes the structure, and the writing changes very little.'

Sometimes the editor comes up with suggestions as to how the story can be improved, although James doesn't generally allow that. 'What the reader reads should come from the author. An American agent has written a book about writing the blockbuster novel. In an interview he mentions an author who sent in his manuscript, to which he responded with a ten to twelve page letter suggesting changes. The author sacked his agent. The agent said that this author was too used to people in England saying how wonderful he was. That author was me. Nobody in England has ever told me I am wonderful. The agent's idea of writing is that you write as a team with him. I'm a great believer that the author is the author – not a committee member.

'An author does need an editor and can use some suggestions if they are sensible but there's a limit to what an editor can do. Editors are valuable but there is a line over which they should not step. An agent as editor and co-author is a very boring way to work, and writing novels is hard enough without making it twice as difficult.'

Writing may be hard work but it's something James Herbert doesn't shrink from. After attending a local Catholic school in the East End of London he passed a scholarship exam which enabled him to attend St Aloysius, a strict grammar school run by priests in Highgate, London. He was born on 8 April 1943 in the East End and his parents were street traders who lived at the back of Petticoat Lane, Whitechapel, once a haunt of Jack the Ripper. He has two

brothers. He married his wife Eileen when he was twenty-three and has three daughters.

After grammar school, he studied graphic design, print and photography at Hornsey College of Art, and his first job after leaving was as a paste-up artist in an advertising studio. He became a typographer at a leading London art agency two years later and was then promoted to art director. At only twenty-six he was made group head, handling £5 million-worth of business and flying round the world. But something was missing.

Hearing the advertising copywriters talking constantly about the novels they planned to write (but never did) sparked him into action but he kept it quiet when he began writing his first novel at twenty-eight. *The Rats* was accepted and published by the New English Library in 1974. He tried six publishers, only three replied, and only New English Library wanted the book. All six manuscripts were sent out on the same day.

The Fog followed in 1975, *The Survivor* in 1976 and *Fluke* in 1977. But it was only in 1978 that he felt confident enough about his writing to give up the day job. Prior to this, he was coping with all the stresses and strains of working for a large successful agency as well as writing his novels. He wrote during the evenings, weekends and holidays.

He moved with Eileen and his family to Sussex in 1978 and his enthusiasm for writing hasn't faltered. *The Spear* was published in 1978, followed by *The Dark* (1980), *Moon* (1985), *The Magic Cottage* (1986), *Sepulchre* (1987), *Haunted* (1988), *Creed* (1990), and *Portent* (1992).

Despite being known as a horror writer, particularly as he made his name through *The Rats*, James Herbert says that he would like to draw readers' attention to the fact that horror can be infused with writing that draws on ideas from other genres. 'I've tried to do different things each time. I don't want to do the same thing over and over again. I've written overt horror as in *The Fog* or romantic horror as in *The Magic Cottage*. *Creed* was humour and horror. I keep trying to develop all the time in different styles. From *Haunted* to *Creed* to *Portent*, you'd almost think that the novels were written by a different author, particularly in terms of content and style.'

He refuses to discuss what fear means to him and how he

expresses it, although it is the thread that runs through these disparate elements. 'Fear and horror cannot easily be defined. It would be like asking a comedian to define humour.' He agrees, however, that in his novel *The Spear* readers can experience fear on several levels. There is the symbolism of the Heilige Lanze (Holy Lance), said to have once belonged to Himmler, which sets off images of Hitler and the Holocaust, and events which evoke a fear of the supernatural and the unknown. The Lanze perhaps provides a point of contact between a fear of the ghostly and undead, and the evil in human beings themselves. Any ghostly and supernatural events within the novel are counteracted by scenes which invoke the evil of World War II.

James Herbert says that certain novels have allowed him to express different ideas sometimes in a way which includes vivid violent images, but which can also be read on different levels. James Herbert grew up in a house condemned for street clearance and saw the ruins of the East End crawling with vermin. 'In *The Rats* there were certain levels of understanding. I was making social comment. Half of my street was blown away in the war and was alive with rats. The East End was so neglected by successive governments yet only five minutes away there was Moorgate and the City, a huge financial centre. But we were living in poverty. I wanted to tell the readers that this is what happens in inner cities.

'With the next novel in the sequence, *Lair*, I moved the story out to the suburbs, and in *Domain*, the third novel, the rats destroyed the perpetrators of the system that had created them. Neglect and nuclear experimentation engendered them and this was created by the Establishment.' He explains: 'There are underground bunkers underneath the Embankment in London with exits as far as Heathrow. The elite of our society will go in these bunkers if there is a nuclear attack. The rest of us will get locked out. The irony is that the elite escape the holocaust but are driven out by the evil they created. *The Rats* novels are a metaphor for neglect, as well as the effects of nuclear experimentation. The rats are also a vehicle for horror.'

It was important to James Herbert to be able to touch his

readers by giving this intimation of reality. 'The novels allowed me to write a new kind of horror from street level. Before that most horror wasn't very accessible, with novels about upper-middle-class people such as in Frankenstein or Dracula. *The Rats* novel launched my career because it brought horror down to ground level (literally, you might say) and was accessible to the ordinary person in the street.'

As a father of three girls, he admits that the violence in his earlier novels may appear excessive to some people. 'My horror knows no bounds; I dislike censored horror. Horror is so horrific that you have to tell it for what it is. I have been criticized for introducing characters and then suddenly killing them off, but at least I tell you something about their backgrounds. I was sick of films where people were anonymous. People have families – wives, children, a dog, for example – so it's important for me that my readers can empathize with the characters when they are killed. The readers must have some sympathy for the characters or at least know these characters had lives.'

James Herbert says that his books have become less violent, on the whole, as his writing career progressed, but that they do fulfil a function for some readers. 'Violence is cathartic – cathartic for the reader and for me. The readers are the reality and the scenes show how violent some people can be.'

One of the scenes often mentioned by critics occurs in *The Fog*, in which a man has his penis hacked off by a scissors-yielding madman who has been affected by the deadly man-made vapour. Finding a point of contact between a valid fear, such as crossing a busy road, and an almost surreal terror is something at which James Herbert excels. The action takes place in what is an instantly recognizable boys' school, full of jealousies and secrets, which is plunged into an orgy of violence through contact with the fog.

One of the ways he draws readers into sharing the foreboding and fear of his characters is by changing the narrative viewpoint. 'In the early days the writer Edgar Rice Burroughs would have a hero who would be caught up in a dramatic situation and the story would switch into a new

chapter or totally different scene and back again to the main story. It really took me along with it. I couldn't wait to get back to the first chapter and back again to the new thread. When it works, this technique works wonderfully.'

It's a technique which he often uses in his own novels. 'Quite often, I write about a city or world disasters on a grand scale, then cut to a character who has initially nothing to do with the story, but becomes affected personally. It brings the novel down from a vast, overall scenario to a more intimate level. It gives the reader a dual idea of the horror.'

As a Catholic James says he was steeped in the supernatural, and his grammar school was run by priests, an experience which turned him almost – although never completely – away from Catholicism. If there have been any incidents in his life which have led him to write about the supernatural, he's not telling. 'There is none that I would like to talk about, but most of my work is based on speculation. For instance, if I write a story about reincarnation – as with *Fluke* – it doesn't necessarily mean I believe in reincarnation.'

A further element which draws readers into the reality he is creating on the page is his sex scenes. James Herbert comments, 'I'm supposed to be the best writer of sex in the horror genre, but the truth is I'll only include sex if it is relevant to the story. When I write about sex, the hero enjoys sensitive sex. With the subsidiary characters, it's usually sex with humour – great graphic details. Over the years I've given three talks at Oxford University and last time a student told me that he had learned about sex from my books, which in a way, was what I'd intended. My sex scenes are never "Wham, Bam, Thank You, Mam."

'Drawing people into a novel can be achieved through writing about their most mundane situations and then taking that mental leap and inviting the reader to go with you. I can do a scene about characters sitting at a kitchen table – what can be more mundane than that? – and make them take that leap into something else. Particularly with the main character, I ensure that he or she is a study of emotions, psychology, anything to do with feelings.'

Despite the apparently random and shocking events that

appear in his novels, a great deal of planning goes into them. He writes in his study six days a week. Before he begins writing, he usually spends 'five minutes' thinking about it beforehand. 'Sorry, a joke, but sometimes an idea does get started very fast. The research for a novel usually takes about three months, but always continues during the writing.

'First of all I have an idea, and that can stem from a magazine or newspaper article, movie, TV programme or conversation. Ninety per cent of the time, however, the idea just appears in my mind. The next stage is to research the idea, and I get as much research done as possible before I start writing, although there are always more ideas to insert when I'm actually writing the novel. I buy several large notebooks in which I put pieces of research, and one or two smaller notebooks which I use when I am writing the novel. I have another – a mid-size notebook – which I use for ideas and names of my characters.'

Getting the right name for his characters is of immense importance for James Herbert as he says it colours the whole effect of the novel. 'I get names from films, the *Radio Times*, telephone directories or even my daughter's graduation brochure, for example. I write down possible surnames and Christian names. If the name doesn't gel it causes problems as the individual characters don't seem very real in my own mind. I think to myself, Jack with Smith doesn't work; perhaps I could try John with Smith, for example? I am always looking for a real listed name; something that's a bit different. Often I change the name of a character mid-book if I'm not satisfied I've got it right.

'I write small studies of the main character, giving general appearance, colour of eyes, and who the parents are if relevant to the story, although my idea of what the story is may be quite vague.'

James Herbert goes through this process for all the characters and also puts down one-line ideas that occur to him as he's researching. 'These tend to be general ideas and small incidents which may later appear in the novel. At the end of the day I'll have about 130 and will continue to add to them as I get more ideas. Out of these 130 ideas I may eventually use about seventy.'

The notebook will also contain words which James Herbert finds that he is repeating as he thinks about the novel. 'One of the words for me is "see". I try very hard to find alternatives such as "look", "view" and "visualize". Words and phrases come into my mind such as "glance" "steal a glance".'

Despite the shock elements of some of his books, which initially appear disparate but eventually knit together at the end, James Herbert says he never plans a book. He tried it once and got very bored. 'I have a rough idea of where I am going but I never know the ending. How it is going to be resolved is always a nightmare. It's a very worrying time for me when I am writing, wondering what the hell the novel is all about and how it is going to be resolved.'

There has to come a time, however, when the notetaking has to stop. He starts writing, weaving in all these elements, until he has written six or ten chapters. From these initial chapters, he makes a note of what happened in each chapter. 'I rarely read them back but the notes are useful if I need a quick reference.' He explains, 'My notebooks are page-numbered so that I can go back through them but it doesn't mean I stick strictly with what's in them. My chapters ran to twenty-nine in one notebook and yet when the book was published it had forty.'

James Herbert gives other examples of the notes he writes for himself. The notebook for the novel he's just finished, (*The Ghosts of Sleath*), says 'Note Number 101 – Mass of flies where ghost stands – number ideas.' Number 102 says 'Musée de Cluny – Grace refers to religious works of art – impossible not to be touched by religious atmosphere. The hero is asking Grace about religion – chronicles.

'At the end I'll have an index to the whole notebook which will give the page numbers in which the events are noted in the notebook. If I look at the index at the back of the notebook I can see the names immediately which means that I don't repeat a name. If I want to look back through the notebook to see what I wrote on page 30 I will find a reference to that page in the index. The numbered notebook is my chief tool when I am writing a book.'

Although unwilling to talk about any events which led to his

interest in the supernatural, he is superstitious about the notebooks and pens he uses. 'I used to work with the W.H. Smith Jumbo 10 x 8 notebook and a Pentel pen but these are hard to find. However, I've found a shop in Brighton that sells a pen which is not too fine or thick, and work through from chapter one. Nowadays I use a W.H. Smith thin Pentel for my first draft – I'll write a chapter in the thin Pentel and then copy that out in a thicker Pentel.

'When I start a chapter I plan chapter one and go through that, making notes on up to eight events which will happen in that chapter. Then I'll write that in a shorthand notebook. It gives me some idea of what is going to happen in that chapter. When I am actually ready to write the chapter ideas occur as I write, with every sentence leading on to the next one. I like to give myself the freedom to change the story as I am writing, which is why I don't tie myself down to a strict plan.

'In another shorthand notebook I write down awkward sentences, perhaps reworking the structure of a sentence. Writing gets harder the more you do it, not easier. It's because you've written so many times in the past and you have to avoid the clichés you've invented yourself. I've introduced things that have become clichés and need to constantly find new ways of saying things – and that's difficult. I rely on *Roget's Thesaurus* more and more these days.'

Searching for the exact meaning or phrase that seems right to him takes a lot of energy. 'I can be stuck on one sentence for an hour. It's writer's block. There are certain authors who are good storytellers but they are not good writers. I envy them. People say that I am a prolific writer, but I don't feel I am because I'm too conscious of the writing itself to do it in haste.

'At the end of the novel, I start again from the beginning and read it back until it's finished. I never read back through it at the end of each chapter, however, as I feel that would interrupt me. I then make any changes and it's ready for typing on the word processor by my wife. I read through the manuscript again and make further corrections until I'm satisfied I can take it to the publisher.

'I'm my own best editor. If I've slaved over something that doesn't feel right when I'm reading through I'll just delete it

entirely, even though I'm only too aware of the pain or effort it took to write it in the first place.'

When James Herbert got to the final chapter of *The Dark*, for example, he realized that the ending was too profound. 'The whole book was profound but the end was overtly so. I could see that I had lost sight of the main characters. Instead of intimate studies of the characters, the chapter ending had become a worldwide story. I scrubbed the whole chapter and rewrote it with a more intimate basis.'

The final copy – James's immaculate typescript – is nearly ready to present to the publisher. 'I always take great pride in the way my work is presented, probably because I used to be in advertising. I photoprint a cover then spiral bound the mss and insist on giving it to the publisher in person.'

James Herbert, who relaxes by playing the guitar when he's not writing, has shelves full of books on the supernatural and the paranormal. He enjoys reading Arthur C. Clarke and H.G. Wells, although his reading is eclectic and covers many genres. Cormac McCarthy, writer of *Blood Meridian* and *The Evening Redness in the West* is admired. 'These novels are very portentous, with purple prose. They are wonderful, bizarre and dark – and westerns.' This is confirmation, perhaps, that James Herbert does not see the writing of any novel to be limited by the accepted customs of that genre.

6

Elizabeth Jane Howard

Elizabeth Jane Howard was born in 1923 in London. Her parents had a timber business and she grew up partly in their country house in East Sussex with several cousins. Her first novel, *The Beautiful Visit*, was first published by Jonathan Cape in 1950, and won the John Llewellyn Rhys Memorial Prize when she was twenty-five.

Before becoming a full-time writer at the age of forty she had held a variety of jobs. Her first was as an actress and she has also worked as a model and secretary. After the success of her first novel, she wrote *The Long View*, followed by *The Sea Change*, *After Julius*, *Odd Girl Out*, *Something in Disguise* and *Getting It Right*. The novels are published by Macmillan in hardback and Pan in paperback. Ms Howard has also written fourteen television scripts, a biography of Bettina von Arnim with Arthur Helps, a cookery book with Fay Maschler and two film scripts. This is in addition to editing two anthologies and publishing a book of ghost stories.

Currently working on the fourth and final part of *The Cazalet Chronicles*, *Volume I*: *The Light Years* was published in 1990, followed by *Marking Time* in 1991 and *Confusion* in 1993. *Casting Off*, is the title of the volume in progress.

Ms Howard married naturalist Peter Scott, son of the eponymous captain. She prefers not to mention her second marriage, and her third was to Kingsley Amis. She has one child and four grandchildren and lives in Suffolk.

'I never intended to be a writer; I just found myself writing when I was eight. I was very interested in theatre when I was young and wrote plays. One of them was accepted and bought but World War II came and got in the way of that. I didn't become a writer until I started *The Beautiful Visit*, which was originally a short story that seemed to be turning into a novel, so I thought I would have a go at writing it. Writing just happened to me. I think it does to some people. I don't think you plan to be a writer. It's not a very desirable practice; it's very solitary.'

The Cazalet Chronicles are set between 1937 and 1947 and revolve around a family living in a country house in Sussex who run a timber merchants' business. 'I wanted to write about that period in this country. So many things changed during those war years that it seemed to me the best way of dealing with this was by writing a family saga.' She cites examples. 'The war changed the way people lived. It affected every single person. Food rationing undoubtedly made a healthier nation. Rations were tight and I remember always being hungry as a child, although not desperately so. When the war began, people of my sort had servants and people like my mother couldn't boil an egg. By the end of the war they were all good cooks.

'In my generation it was rare for girls to go to university, and I didn't really know much about that. It was thought perfectly proper to educate the boys but not the girls seriously as they were expected to marry. Before marriage, girls were allowed to become secretaries, domestic servants, teachers or nurses, but the idea of being a doctor, lawyer or anything demanding such as an MP, was unusual, although there were always a few exceptions. Today it would be extraordinary for women not to be given that chance.'

She admits she would have loathed being a parent in the thirties, as the only work in which married ladies were encouraged to dabble was charity work. 'They didn't do it in

the serious professional way that people do now and many women were bored. My mother had been a dancer before she married my father and had to give it up. Being a married lady with nothing to do was a very different life from touring with the Russian ballet.'

Other features of life that we take for granted in nineties Britain were unusual then. 'We never went abroad as children at all. Our parents went abroad occasionally, but people didn't travel in the way they do now. I didn't meet an American until the third year of the war. I didn't see a black person. All those things are completely different, and the idea of a multiracial society hadn't been contemplated.'

The radical upheavals in the period 1937 to 1947 meant that the position of women changed dramatically. 'Women worked in factories to help the war effort because there weren't the men to do it. But in the services, however, women were still expected to be the bureaucratic clerical domestic cleaner-uppers, while men went away and did all the dramatic and interesting things. I think it's a very good thing that it's changed but we are still changing and have a long way to go.'

Ms Howard also had personal reasons for wanting to write about this period. 'I was writing about my youth, and have a very clear recollection of it, much clearer than my later years. It seemed sensible to write about the kind of family I knew. For the first time, I used several people that I knew – the governess, Miss Milliment, for example, was my governess. Rupert is not completely based on an uncle, but I did use a lot of him. The girls, Polly, Clary and Louise, are me split into three with bits added to them.'

One of the themes that she explores in the *Chronicles* was the way that adults kept children in the dark. 'They were constantly ambushed by events or happenings.' She cites as an example the slow death by cancer of Polly's mother, which was not fully explained to her. 'That was thought to be the right way to treat children then and I think that it would be generally acknowledged now that it was not at all the right way to treat children. If there are things that matter to a child they must be told the truth, and not have it fudged or evaded.'

Ms Howard's working method is slow and methodical. She

produces only one draft, editing daily as she goes along. 'I try to work every morning, because that seems a good time to do it. As the book progresses and I get short of time, I usually write most of the day, although I have time off after lunch as it is a very bad time for writing.

'I start again at about 4.30 to 5.00 p.m. and continue until 7 p.m. and read through that morning's work. I do an enormous amount of re-reading and read the narrative aloud to myself. If I have trouble reading a sentence aloud, it usually means that there's something wrong with it. It might just be that certain words don't go very well together, or they may have the sense but the sounds are repetitious. Perhaps I am making a character say something too slowly or too fast. These are some of the things that you can control as a writer.

'Towards the end of a novel I sometimes get a high, usually after a day when I think I have done a good scene, but it's not very often. Most of the time I don't think the novel I am working on is any good. It's very, very depressing – and that's where a good editor comes in. Jane Wood at Macmillan cheers me up and I trust her judgement. Most of the time it's really hard. I often feel very disparaged and it doesn't get any easier. Some people write x thousand words a day and don't find it at all difficult as they have a compulsion to write. I don't have that. I love being interrupted and often I'd rather be doing something else, but I feel writing is all I can do. It interests me. I've tried not writing and I felt worse.

'Writing is the most difficult thing I've ever tried to do and it goes on being difficult. But that's interesting and challenging. However badly I think I've written a novel, I always think I can do it better, and it's the same if I think I've written the novel well. The blank page could have anything on it; that's what makes it a challenge – and what makes it fascinating. I think I can tell when I've written a good passage but I may not be right. Sometimes I think I've written a scene and it's really come off in the right way, but at other times I feel it could be much better if only I knew how.'

On holiday in a very hot country, Ms Howard learned to use a typewriter as it was too sticky to hold a pen. There was an added bonus. 'By typing my work, I found that my response

to it became more impersonal. I could look at it more clearly than when it was in my own handwriting and couldn't really have judged the material so well. I would find it very difficult to do it any other way today. One gets into a way of doing something. If you find out how to do it, you're lucky and then you usually stick with it.'

Despite the detail which goes into her novels, Ms Howard doesn't write an outline before she starts writing, although she acknowledges that many writers do. 'I know roughly where I am going to end up but I don't like really knowing how I'll get there in too much detail. If I knew everything before I started writing I would get terribly bored. Writing a novel has to be a bit of an adventure for me too, which makes it a slower process, of course. Usually when I get really stuck it's because I haven't thought of what it is I want to do. If I can manage that, I can get over the difficult bit.'

Some notes are made, however. 'With all my novels I keep an age chart and a salient dates chart because it's a frightful bore to keep counting it up and getting it wrong. With *The Cazalet Chronicles*, I put down the war dates because although I remembered the war well overall, I didn't necessarily remember the days on which the events happened. During the process of writing these novels, I discovered memories which I had forgotten. It's rather like reading letters that one wrote thirty years ago and hardly being able to recognize yourself. You may not even remember what the letter is about, and have really to think back to get to it.

'When I start writing, I know quite a lot of the things that are going to happen, but I don't know everything. I am always feeling my way a bit.

'Prior to *The Cazalet Chronicles* I'd never written a saga, so I'm not an expert, but I can say that it's given me the room to write about people in the round. In a short story, the material has to be much slighter if you are going to bring it off. A single novel gives you more room than a short story, but you've got even more room in four novels to develop your characters. In a saga, characters can be almost unrecognizable in the final novel. Zoe, for example, changed enormously in the novels; she grew up in one way or another. But in a single novel it

would be very hard to do that unless she'd been the principal character and the whole novel had focused on her changing. Here she was just a part of the narrative.'

The novels took about eighteen months each to write and Ms Howard feels that she has been working much too hard. 'When I finish *Casting Off*, I'm going to have at least three months off. I haven't had more than two weeks' holiday for the past four years and you get to need it. Just to relax and not worry. When I'm writing I have to become that situation or be that person, and it's what makes writing tiring. You are drawing stuff out of yourself all the time.

'You can wake up in the morning absolutely sweating with anxiety because what you did yesterday you might no longer be able to achieve today. That's one of the things that's quite frightening about writing. But on the other hand, usually I find that after a certain distance, things which you hadn't consciously thought of start falling into place. Then you know it's going better. If this isn't happening, it's very worrying.'

Discrimination is an important tool for any novelist, she asserts, saying that choosing what you are going to tell the reader and what you are not is crucial. 'I know a lot more about the people who are in *The Cazalet Chronicles* than I reveal, but it's always a question of asking what is relevant to the reader. I ask myself what they need to know, not what they don't.' Occasionally the novelist might choose to tell the reader the same thing in three different ways. Perhaps the same event is detailed from three different viewpoints, a technique Ms Howard uses in the *Chronicles*. But you must be convinced the repetition works. 'If I start boring myself, I'm boring the reader. Sometimes I can see that the narrative is going nowhere and I stop for the day. But it's not a good idea because it's very hard to get started again. It's far better to end the day's work in the middle of a sentence so that you can get going again.'

Despite having been a successful novelist since 1950, Ms Howard is still never sure if her novels have enough pace, however. Part of her technique, and the way she creates momentum in her novels, is to have a character's actions or qualities trigger off associations in another character's mind

later on in the novel. In *Marking Time*, for example, Clary sees her father, Rupert, eating the skin off his milk and files it away in her memory. When he is lost during the war she writes to him, reminding him of this habit. Towards the end of the novel, Rupert is described repeating a similar action under very different circumstances. 'I use earlier material and don't waste anything such as the reference to the skin on the milk. Clary, who has a rare capacity for love, remembered the way he did it, which I described, and when Rupert eats the skin off his cocoa on the boat he is thinking about love.

'This is what happens in life. You have conscious and unconscious memories. Rupert has an unconscious memory when he is talking about love and eating the skin off his cocoa, particularly when you remember that he actually loathes the skin. When Clary records it, it is a conscious memory. People operate on many levels in this way.'

Ms Howard believes that aspiring writers should, on the whole, write about what they have experienced, although she acknowledges that there are some types of research that can be made to work. Deciding whether to investigate something about which you know little will depend on the kind of novel you are writing, she says. Ask yourself how the historical and social setting of your characters determines the way they think. 'There are very subtle differences of language, and one of the things I discovered when writing *The Cazalet Chronicles* was how astonishingly naive the adults were politically, how cut off this island was, although it was a big world power through its empire.

'I take novels very seriously. They are a way to learn about people and the society which they live in, because many things don't change. There's always a paradox of perspectives. Novelists write about human nature between a spectrum. Everyone is capable of feeling jealous and everyone's fingerprints are different. There's a lot in between. Any novel will tell you things which you might learn in your own life, but you might not, so they are very useful in that way.

'My novels are written from many subjective points of view. The point of view of the characters I write about is not what I think. I don't have any omnipotent narrative or judgemental

captions concealed. The viewpoints record how that person is behaving, there, then, for better or worse, making mistakes, getting it wrong, only understanding some of it. That's how we all are and how we live. We have no other way of doing it.

'If you look back over your own life you can see when you've done something silly, awful or something rather good. You can consider events dispassionately because they're over and you're living in your own present. Setting novels in the past enables me to do that, and in this case, I could look back to my youth and see many things I couldn't see at the time.'

In *Marking Time* the main characters, Polly, Clary and Louise, are created from single-section viewpoints, which the author acknowledges can cause problems. 'It's essential that you don't leave a character for too long. Writing a novel is like stretching out a washing line and you start the reader at the left-hand post as their eyes travel along the line. As the author, you have to use your peripheral vision, keeping the whole line in mind the entire time you are writing, although you may be here or there in the narrative. You must keep it balanced.'

Ms Howard is unsure whether she will use the device of single-section viewpoints as much in *Casting Off*. 'The girls are much more together and there are new characters coming in all the time. Using the sections seemed the right thing to do with the earlier novels because children do lead, in a sense, very secret lives, and are isolated because of their imagination and view of events. I wanted to establish them very clearly so I gave them quite a lot of room.'

Most of the sections of Ms Howard's *Chronicles* are divided by year and from this she decides roughly how many chapters she needs. *Casting Off*, for example, deals with the period from VE day to the partition of India in 1947, and will be in three sections: 1945, 1946 and 1947. She may not stick exactly to that rough plan but says that the frame of war events is useful. 'Taking each year as a rough structure is quite useful, although it isn't as if events start at the beginning of the year and end in December. They don't, but it gives me a space within which to work.'

Using flashbacks in each section is a technique which she uses skilfully. She explains, 'I think they are necessary,

because it's astonishing how little most people live in the present. They spend an enormous amount of their time recollecting things that have happened, or anticipating things they hope or dread. The flashback is now so recognized that it's not considered to be a gimmick any more.' Some writers advise that the flashback be used, sparingly, if at all, because it impedes the forward momentum of the plot. Ms Howard comments, 'There isn't a rule which can't be broken if there is a good reason for it. That's why there really aren't any rules for novel writing.'

She is very strict with herself, however, 'The rule that I lay down for myself is that it should be clear. A book should be eminently readable the first time and readers should be able to get a lot more out of it the second time. Clarity is vital, which means trying to be simpler – and is much harder. Any writing which reads easily has usually been sweated over by the writer.'

The reader must not be bogged down by continually asking questions of the narrative, she says. 'In music, for example, you never have to ask the question, What? at the end of a phrase written my Mozart. There are musicians where you do have to do that. This means that you're not getting the next phrase because you're still wondering about the last one. If you are making the reader contemplate a paragraph three times to understand what's going on, there's no pace to the story. There isn't a flow or a dynamic charge at all.'

Being aware of your limitations is a useful way of discovering who you are as a writer, thinks Ms Howard. 'This applies to whichever novel you consider. People can't write more than they are. There is a band, like the aura around the moon, which is pure imagination. If writers use that imagination and not experience, knowledge, or education, they may be all right, but it's a very narrow band and they have to be careful not to go outside it.' Where there are shortcomings in novels, asserts Ms Howard, it's nearly always due to the author not knowing enough about life and having a deep enough understanding of human nature. 'When I've finished a novel I have to have a fallow period because I haven't got anything more to say. I want to have a bit of life

again, to keep on going. Every novelist has to do that. It's difficult to write about what you haven't really experienced. I've written about the timber business, publishing and some of the arts, because I know a little about them, but I would be chary of writing about a City stockbroking firm. I don't know enough about that life, although somebody who did could use it as a base for a very good novel.'

Occasionally pure imagination can work, but only if everything else is in place. She gives an example. 'The novelist Elizabeth Taylor wrote a marvellous novel about a widow who is not really wanted by her married daughter, and goes to live in an old people's hotel in Cromwell Road, London. It's immensely dreary and as the old people can't be nursed there, they end up somewhere nastier still to die. They are very lonely, have rather horrible rooms and meals become rather important.

'Elizabeth stayed in a hotel like that so that she could find out how the widow and these old people would live. She needed to know what they ate for dinner, whether the lift worked and what the chambermaids were like. This is the sort of research you can do that increases your knowledge of such places. But another type of knowledge comes only from living with, experiencing and observing people, recognizing your own feelings and knowing yourself very well. The worst lies people tell concern themselves rather than other people; that's what I really meant by not being able to write more than you are.'

As far as dialogue is concerned, Ms Howard says that art is not life and therefore people don't speak in them as they would in real life. 'What dialogue has to do is give the *appearance* of how they would sound. That means a great deal of honing down. If you look at radio scripts or transcripts of people's interviews, you'll find them saying er and um and repeating themselves over and again. It wouldn't be tight enough to be repeated in fiction.

'Writing dialogue is a facility that some novelists are born with and then they get better; some people simply can't hear voices. It's rather like being tone deaf. Such people write very unconvincingly and their characters say very unconvincing things because they have no ear for dialogue.'

One way of improving your dialogue is, of course, to study

those who have no trouble with it. Ms Howard says it's vital for aspiring writers to read very good novelists. 'Become familiar with what's been previously done, because it will keep your standards up. Don't worry if you fear writing in a pastiche of a writer who has influenced you. It will wear off. Think about what you really want to do when you are writing, but don't exhibit self-consciousness. It's a doubled-edged weapon.

'A writer has to be extremely self-conscious in the sense that he or she should be conscious of themselves and what is going on. But there is another type of self-consciousness which particularly describes very young writers where they say, "Look at me writing." Make your words move you as you are writing. If you don't feel interested, involved and moved by the people you are writing about, don't expect anybody else to be.'

Ms Howard advises aspiring writers to read as widely as possible. Look at all types of novels set in different periods and the various approaches novelists have taken. She recommends Elizabeth Taylor, the writer's writer. 'Her novels are very traditional novels, and an addition to Jane Austen. Their matter is not very great but she deals with what's there so well. She's also very funny, which is important, I think.'

Saul Bellow, Muriel Spark and Evelyn Waugh are among her favourites and she mentions Hilary Mantel's *Fludde* as a fine contemporary novelist. 'Consider reading novels by writers who are not as well known, however. Sybille Bedford, for example, is very good. Try her novel *Jigsaw*.

'When I am writing, I don't read very many novels but enjoy biographies, essays and some poetry. Sometimes I reread *Anna Karenina* or *Persuasion* for the millionth time. Reading ought to be like food. I don't think one ought to be at all highbrow about it. John Bayley, the very good critic, is a marvellous person in that respect. He reads everything from *Woman's Own* onwards.'

Ms Howard was married to Kingsley Amis for eighteen years and the question has to be asked: how is it possible for two novelists to live together? Surely there must be some jealousy or rivalry? 'Not at all,' says Elizabeth Jane Howard. 'You can talk to another writer in a way that you can't quite do with anybody else.'

7

P.D. James

'The detective story is written in accordance with certain very well-recognized conventions. There is a central mysterious death and a closed circle of suspects with means, motives and opportunity; a detective, who can either be amateur or professional, who comes in to solve the crime; and clues to the mystery, which are inserted into the book with cunning but essential fairness. At the end we expect a solution which the reader can arrive at through logical deduction from these clues.' That is the structure, says P.D. James, who acknowledges that some people might see it as a formula, and agrees that it imposes certain constraints on the writing.

But what else distinguishes crime and detective novels from other types of fiction? What are the essential elements? 'Strong narrative thrust. The story is very very important. The characters and setting are for me equally important; nevertheless most people reading a crime novel or detective story (which is a species of crime novel) expect a strong narrative interest. Excitement, thrill and puzzle are the distinguishing elements.'

P.D. James wrote ten of her novels while working full-time for the Civil Service, only retiring six months before her sixtieth birthday, in 1979. She was born in Oxford in 1920, the eldest daughter of a Civil Servant father and housewife

mother. Her father paid for her to attend Cambridge High School for Girls.

Having left school at sixteen, she joined a tax office in Ely where she was very unhappy. Then the war came and after a stint working in the Festival Theatre, Cambridge, as general assistant manager, she took up nursing. In 1941 she got married and came up to London, where she worked in a food office in Marylebone. Her husband returned home from overseas service in the Royal Army Medical Corps unable to work. By the time the war ended she had two children and had to earn a living.

From 1945 onwards she worked as an administrator in the National Health Service before entering the Home Office as principal in 1968, working first in the Police Department concerned with the forensic science service and later in the Criminal Policy Department. It was this experience which she was to find so helpful when depicting the police and forensic science procedures in such acute detail in her novels.

'When I was concerned with the Forensic Science Department I had no reason to visit a mortuary, but I did see one mortuary and a dead body when I worked as an administrator in the National Health Service. However, I did visit forensic science laboratories, when the scientists explained the investigations they were doing, for example on samples of blood or on clothing. In my novels I try to be meticulous about research and to get the medical, police-procedural and forensic details right. The writing should be vigorous and realistic if the reader is really to believe that he or she is there.'

She has twice been a winner of the Crime Writers' Association Silver Dagger Award for *Shroud for a Nightingale* and *The Black Tower* and was awarded the Diamond Dagger Award for crime writing in 1987. *Devices and Desires* was shortlisted for the 1989 Daily Express Book of the Year. P. D. James continues to write fiction, and is a Fellow of the Royal Society of Literature and of the Royal Society of Arts. Until 1993 she was a governor of the BBC, a member of the Arts Council, and British Council board member. In 1983 she received the OBE and was created a life peer in 1991.

So how does she get started? 'The first inspiration is usually the setting. I have a very strong response to what I think of as the spirit of a place. I can be on a lonely stretch of beach or at a sinister house or in a community of people such as a forensic science laboratory or a nurses' training school and feel strongly that I want to set the book there.

'From setting, next come the characters and after that the details of the plot. Then the clues and denouement, and I construct them very carefully over very many months. The construction, the plotting and the planning take as long, if not longer, than the actual writing.'

Devices and Desires deals with murder at a Norfolk nuclear power station that overlooks the sea. The novel interweaves the lives of the staff and two protesters and a baby living in a caravan on the headland nearby. P.D. James recalls what sparked off the idea for the book and the feeling for place that it gave her. 'I went to Southwold in Suffolk and remember thinking that the sea hadn't changed for a thousand years. And then I just looked north and saw this great power station overshadowing the headland, and began thinking about the ruined abbey and the converted windmills which used to produce the power, and the artefacts of my own generation – pill boxes, for example – against the German invasion.'

P.D. James moved the setting of the novel into Norfolk to negate possible libel problems, and found that the characters began to spring into her mind. She explains, 'I asked myself, Who is doing the murdering? Why? Where? When? Will it be somebody from the power station? What are the motives going to be? I began thinking of the community of people who would be living on the headland. Over the months, these people came into my mind, and I began to make copious notes, using fifteen notebooks. I spent a day at Sizewell and another at Winfrith in Dorset and the station staff were all very helpful to me. I also read several books and pamphlets about nuclear power.'

Where her characters come from, she is not sure, and comments that the creation of characters is mysterious, even for a writer. 'I find that the characters come into my mind and I get in touch with them, as though they are real people in

some limbo of my creative imagination, and they gradually reveal themselves to me. I have some idea of who the characters are before I start writing and see them in my mind's eye. I see enough of them in my mind's eye to be able to describe them, but it's more important to me to understand them mentally.'

Police Commander Adam Dalgliesh, for example, is the main character in *Devices and Desires* and has appeared in several of P.D. James' novels. 'He is not drawn from real life but has the qualities I admire in men and women – courage, independence, intelligence and sensitivity. I wanted to create a credible professional policeman who also had an artistic interest. I wanted him to be a sensitive and complex human being and so I made him a poet. The advantage of having him in a series of books is that he can develop and I can get to know more of him and hope he becomes more and more real to the reader.'

When P.D. James began writing in her forties in the 1960s there were very few women who were senior in the police service. As she wanted to write about a senior professional detective, she had to choose a male character. If she was beginning now, however, she says that she might well have chosen a woman as it is now a more realistic possibility.

There are elements of the writing process which P.D. James understands and can explain very clearly, but creating characters is not one of them. 'The characters do change during the writing, sometimes in very mysterious ways. I can't do what some writers say they do and that is to choose a name for their characters, knowing initially very little about them and let them take over and write the book. The constraints of the form do not allow this.'

Some writers say that they write into their characters the traits that they don't like about themselves. 'I don't think I've ever deliberately done that, but it's something very close to that; writers do find in themselves most of their characters. Perhaps if they are writing about a character who is jealous they will look for jealousy in themselves. We all know what it is to be jealous, frightened or nervous. You may not feel like that all the time but you know what it is. I don't think I would

deliberately use it as a way of dealing with something inside me that I didn't like, although I might subconsciously do it, of course.'

In general P.D. James doesn't draw her characters from life, simply changing their names as C.P. Snow and Nancy Mitford did. Aspiring writers should, she says, 'Go through the world with their eyes open, watch and try to understand other people and themselves, their motives and emotions, and then get them down on paper. However, this doesn't fully explain how a novelist creates characters. I don't know the nuclear protesters who appeared in *Devices and Desiers*, for example.'

What makes P.D. James' novels so popular is that she gets under the skin of her victims or murderers in a way untypical of the detective fiction genre as a whole. 'The psychology of my characters has always been important to me but I don't think it was as important for the writers in the 1930s, the golden age of the detective story. What writers then were trying to do was to provide a very ingenious puzzle. The method of death had to be very bizarre and unusual and they liked to have bodies found in rooms with all the windows sealed and the door locked. They liked ingenious alibis and clues and I don't think they were so interested in psychology. I think psychological realism – characterization – was subjugated to the need to provide a puzzle at the heart of the story. I think we've rather moved on from that but it was certainly very true of the early days of the detective novel.'

Being in tune with the age in which you are writing is something no writer of detective fiction can ignore. *Cover Her Face* was P.D. James's first novel, set in the fifties and first published in 1962. It concerns the murder of Sally Jupp, an inhabitant of a home for unmarried mothers who becomes a maid at a large country house, where she comes into contact with people above and below stairs.

'The interesting thing about a detective story is that it's very typical of the age in which it's written. *Cover Her Face* wouldn't be written that way now, because people don't go into homes for unmarried mothers; they are more likely to have a council flat. There isn't the same kind of social

disapproval about illegitimacy now, so *Cover Her Face* could not be written today. It was a book of its time – of the fifties – and we are in the nineties.'

In a similar way *Children of Men* is indeed a book of the nineties, illuminating the concerns of our decade. P.D. James explains: 'I read in the *Sunday Times* a review of a scientific book which drew attention to the extraordinary dramatic and unexplained fall in the sperm count. Western man is only half as fertile as his father. Fifty years is nothing compared to the millions of years we've been on the earth and the decline is astonishing.

'I began to think, perhaps every life form will die out, including man. So then I began to wonder what the world would be like after thirty-five years of world-wide human infertility, when people believed the human race was at an end. It was quite traumatic to write this novel and technically very different from my previous work as it's a single viewpoint novel and drives on in a linear structure. However, it is a crime novel but not a detective story.'

Aspiring writers should note the distinction between crime novels and detective novels. 'Graham Greene's *Brighton Rock*, for example, is a crime novel, as is *Innocent Blood*. They are concerned with a crime, although there isn't a mystery as to who committed it. The reader knows that Mary Duffy in *Innocent Blood* was once an accessory to a murder just as he or she knows that Pinkie is guilty in *Brighton Rock*. There is no need therefore for a detective or clues and a denouement which ties all the threads up in the last chapter. Crime novels deal to a greater extent with the effects of the crime on the victim or perpetrator.'

A novel dealing with a crime allows the novelist to spend more time looking beneath the surface of the plot. The main character (who was adopted) in *Innocent Blood*, for example, knew she was illegitimate but had a barely recognized fantasy that she was the daughter of an aristocrat. Eventually she discovers that she was the daughter of a woman whose actions, along with those of an inadequate partner, led to the death of a child. The novel deals with how the main character, armed with this deadly knowledge, responds to her mother and

adoptive parents, and refines the nature-nurture debate.

'*Innocent Blood* was much closer to a so-called "main-stream" novel, but it was a crime novel because it was a novel of chase and revenge. It wasn't a detective story because we knew Mary Duffy was an accessory to a murder committed by her husband fairly early on so there wasn't a mystery. In a crime novel the interest will probably be in what's going to happen, whether the perpetrator will be caught and the effect of a crime on a perpetrator, the victim or society.

'If you are writing a first novel, it can be very long indeed – long novels are popular at the moment – but sometimes the publishers will say that they don't want it much longer than 80,000 to 85,000 words because they don't want to price it too high. It's probably better not to be too self-indulgent over length, for a first crime novel.'

Before P.D. James began to write *Devices and Desires*, as with all her novels, she had to consider viewpoint. 'With my writing, there are things which I cannot explain very clearly, such as how I create character, but choosing the viewpoint is deliberate. During the writing, I'm saying to myself, "Would this scene be more effective through his viewpoint rather than hers?" I try to change my voice and see events through different eyes.

'Changing the viewpoint adds complexity and richness to the book and enables me to show how subjective experience is. Two different characters may be present at the same event such as the finding of a body, for example, and their response is so different that you wouldn't even know it was the same body. That's very interesting for a novelist; I like to change viewpoint, moving from Dalgliesh's viewpoint to that of his subordinates, or one of the suspects.'

Some writers of crime novels, such as Dick Francis, choose to write in the first person, which gives immediacy, pace and credibility, as well as enhancing reader identification. 'The disadvantage is that nothing can happen in the novel which your narrator doesn't see or experience.'

Has she established a working routine? 'When I'm writing a book, I try to write every day. When I am not writing a book I can go months without writing. It takes about twelve to sixteen months to plot and plan the book and then about the

same amount of time to write it. I might do small amounts of journalism during this time but it's unlikely. Usually I don't do any other writing as I have to do one novel at a time and nothing else.

'When I begin writing a novel, I try and stay in the world of the book, which means I try and do some writing each day. I don't aim to produce a certain number of words or hours each day, but I do try and do about 5,000 words each week, which I think is a good measure of progress. I write longhand and then dictate on to tape, which gives me a good idea of how the dialogue and prose sounds, and then my secretary types it back from the tape and I correct that as the first draft.

'I take out things I don't like but also add new thoughts and ideas, if I think it's necessary. It's mostly a matter of changing words that are not quite right, trying to get writing that's lively and original. It means that I am editing the books as I go along. The next day, I go through the same process and so on until the end of the book.

'Some chapters go very well at first and don't need to be changed very much. These are the chapters that I think are about as good as I can make them, but others are more difficult. In this case, when my secretary has typed it, I check it again and have it retyped until I'm satisfied. Finally, the manuscript goes to a word-processing firm before being sent to my agent, Elaine Greene, and to my publisher.

'I had nothing published before my first novel, *Cover Her Face*. It was a great day when I got home from work and my agent rang to say my first book had been accepted. I still remember that moment – it was one of the great moments of my life.'

How did she get started as a writer? 'I always told stories to my younger brother and sister when I was very young, but I didn't do very much until I settled down to write the first book. Working as an administrative officer in the Health Service in London, I used to go to evening classes by night so I could pass some exams to get promotion, so wrote early in the morning before work and at the weekends. My children were at boarding school, although they were home in the holidays; but it still took a long time to write *Cover Her Face* – about three years.'

P.D. James didn't tell her colleagues at first that she had

become a writer, using her married name at work and maiden name for her novels. Some years later, however, most people had become aware of it. 'I think the Home Office is quite used to having writers in the Civil Service. I wrote eight novels and co-authored a non-fiction book, *The Maul and the Pear Tree* with T.A. Critchley, before retiring in December 1979. I have no idea what makes me write ... I think I must have a psychological need to be a writer. I enjoy it, although it's sometimes very tough work.'

The baroness has this advice for aspiring writers who say they can't find the time to write. 'You have to make time. It's never easy. I appreciate, however, that it is more difficult for women at home with children than it is for business or professional people. If you really want to be a writer you will get up early in the morning. I used to get up at 6 a.m., not terribly early, and set off for work at about 8 a.m., having done about an hour and a half's work.'

Jane Austen, Anthony Trollope, Evelyn Waugh and Graham Greene are among her favourite writers, and she likes contemporary women novelists. She says she doesn't read a great deal of crime and detective stories but classes Wilkie Collins's *The Moonstone* as among the best. Crime writers from the past she admires are Ngaio Marsh, Dorothy L. Sayers and Margery Allingham, while she rates Ruth Rendell, Colin Dexter, H.R.F. Keating, Julian Symons and Margaret Yorke as among the best contemporary British crime writers. She also enjoys biographies and autobiographies.

P. D. James's tip for aspiring writers are:

- Learn to write by doing it.

- Read widely and wisely.

- Increase your word power.

- Find your own individual voice through practising constantly.

- Go through the world with your eyes and ears open and learn to express that experience in words.

8

Wendy Perriam

Wendy Perriam was born in an air-raid shelter in Kew in 1940, a middle child with a sister two years older and a brother seven years younger. Her early memories are of bombs and rationing. She grew up, she says, in a Catholic family in a semi-detached house in a cul-de-sac in suburban Strawberry Hill.

'I always felt that I never quite belonged to my family. My parents were very conventional. My father was a management consultant and very efficient and strict and my mother was a good housewife who worried about doing things "properly". I felt that I was a foundling and couldn't see how I fitted in with these dutiful parents. My mother was extremely anxious, which I think, coupled with a dominant religion, gave me a sombre view of the world.

'Early on I fell in love with God and the Church. When I went to Combe Bank at eleven I became very devout and wanted to be a nun. I think it provided a lot of the drama and emotion that was lacking in my own home. However, there was always guilt and sin to contend with and I wasn't a good candidate for Catholicism.'

When Wendy lost her faith at seventeen she was expelled from her school. 'I was told I was in Satan's power, which was absolutely terrifying. I was devastated and went through a very dark period. It was like being bereaved and I suffered a

major depression. I lost my entire purpose in life. All my friends and family were Catholics, so it was as if there was no longer any world.'

In a state of turmoil and confusion she went up to Oxford to read history at St Anne's College. Throughout her childhood she had been writing, starting with a poem created when she was five, entitled, 'Darling Daddy, Come into the Garden'. The poems and stories continued, but began to peter out when (reluctantly) she found a job as an advertising copywriter.

It was at this time that she joined a writers' workshop at the City Literature Institute in Stukeley Street, London, run by an author called Carol Burns. 'Nobody praised anybody; the criticism was very strict. But I found it was a wonderful training. Carol was a first-rate teacher, and I also listened to all the others in the class and picked up their strengths and weaknesses. I went twice a week and took it very seriously.'

Marrying at twenty-four, she continued working and had a baby soon afterwards, which limited the opportunity. 'My first husband left me, which was another unhappy period, and stopped me writing because I was devastated that he'd gone. Divorce was an extremely painful experience.' But she soldiered on and for a while was a single parent before meeting her current husband Alan and his two children. 'It wasn't until I was thirty-nine and had been remarried for five years that I started writing in earnest again. One of the things which has been good for me as a writer is that I've also known different financial states. I've been very poor, drawing on social security, and I've also known what it's like to be pretty rich.'

Wendy started a second degree in English at the local polytechnic with the idea of becoming a teacher. 'While I was there I started to write for the poly magazine. I took some of the stories I'd produced to the City Lit. (which I still attend). The writer-in-residence there showed them to his agent, Richard Simon, who had a very good though smallish literary list. He wrote to me and said, "I don't know what you're doing at the age of thirty-five studying for a second degree but why don't you give it up and write a novel? I'll try and sell it for you and be your agent".'

Wendy was thrilled, but also in a quandary. 'I'd wanted this all my life, but I was in the middle of my degree and also beset by doubts. Supposing he didn't get it published? However, I knew in my gut that I had always wanted to be a writer, and here was my chance. I gave in my notice to the course tutor and wrote my first novel *in bed* with the covers drawn up to my chin. I was so scared it wouldn't work, I needed my security blanket!'

Absinthe for Elevenses was accepted by Michael Joseph, the first company Richard Simon tried, and published in 1980, when Wendy was forty. 'I was so empowered by this that I was able to start my second novel out of bed!' This was *Cuckoo*, which was followed by *After Purple* and *Born of Woman, The Stillness, The Dancing, Sin City, Devils, For A Change, Fifty-Minute Hour, Bird Inside, Michael, Michael*, and *Breaking and Entering*. All her books have been reissued by Flamingo, an imprint of HarperCollins. She is working on her twelfth novel – the story of the relationship between two female friends – a journalist and a psychotherapist.

'The duty of a novelist is to tell his or her truth. If you offend people, too bad! Nobody has to read your novels; if they don't like it they can always put it down. Being a rebel is helpful; any good novelist will offend somebody.'

Nobody could accuse Wendy Perriam of lacking integrity. Writing is her life and she's determined to tell the truth as she sees it. 'If you've been really fucked about by men, the state or the Church, whatever it is, write about it. Don't worry about being fair. Fiction can be grossly unfair. I think that's how some of the best books are written. Take *Lolita* – child pornography – but what a brilliant book. You don't need to justify yourself. The truth isn't to a literal truth.'

Words, and the words of an artist. 'Some people see me as a sleazy writer because I write explicit sex scenes. This annoys me because male writers do the same with much less comment. I write just as often about religion but critics seem to ignore this. I see myself as a serious novelist, and take a lot of trouble with my style.'

It's essential that Wendy feels she is honest with her readers

and herself, exposing uncomfortable truths about contemporary life. 'I write my sex scenes deliberately to show sex as it is, good or bad. It isn't like the sex in the latest blockbuster, where everybody's got pink pointy nipples, designer lingerie, and achieves mutual orgasms at the drop of a hat. Bodies are smelly and sweaty; people are fickle. You might go off your partner for no reason at all, or feel rage as well as lust. I want to dispel some of the myth that sex is always wonderful.'

Her comments leave you in no doubt that she means business. But how does she write and what does she feel about her books? 'I start writing at about 6 a.m., sitting in my dressing-gown at my desk. I used to work just in the mornings but now I continue until about 4 p.m., partly because I do much more rewriting. But I still write in Biro in longhand in red-covered spiral-bound notebooks, the same way I wrote as a child. I love the colour red. I use notebooks rather than a word processor because I like the tie-up between the pen, the hand and the body, the pace of longhand and the feeling of it being "natural". Having written so much as a child, I want my work to be part of an on-going process.'

Writing a novel is a daunting task for any writer, amateur or professional, and often a Sisyphean labour. Does Wendy have that fear of failure? 'It never goes!' But in order to begin at all, Wendy says she sometimes uses bad handwriting deliberately in an attempt to assuage her fear. 'If I write tidily the whole thing is less likely to work. Once, when I had a really difficult chapter to write, I noticed that my handwriting had got worse. I was coming to the final chapter of a book and it wasn't working, so I wrote it so badly that nobody else could read it and then it worked. There's something wild and freeing about this process, which seems to foster creativity.' There is another worry in Wendy's head that is shared by many writers. 'Everybody fears their creativity will vanish, but you have to live with that fear. I'm quite an insecure person in general.'

So, putting fear aside, Wendy starts work. She usually has two novels on the go at the same time. While she's writing one book she'll be planning the next one in her head and jotting down notes on paper. By the time she comes to write a novel

she has usually thought about it and researched it for a year. The notes are put in a folder marked with the name of the new book, or 'Novel Twelve', if it hasn't yet got a title. 'This includes cuttings and anything about the subject I am planning. Down it goes into the "store", which grows increasingly bigger. During this time I will be continually thinking about the characters, because I need a good long period for them to "brew" before I write about them, and I'll probably be working out the main characters' names, even though these may change later in the process.'

During this period, once Wendy knows her characters, she starts to consider whether she needs to go on any research trips. 'Depending on the setting of the novel, it might be necessary to go to Zurich or Wales or Paris or wherever, so I start getting brochures from the travel agents and jot down all the plans and ideas in the first red notebook. I then read through the ideas which I've been putting down throughout the year. I try to get a rough shape and plan of the book as a whole, who my characters are and when they were born. Their ages are important because of what they can be expected to remember and what they don't know. So, too, are their religion, politics, psychology and whether they smoke or drink, or are married, single, celibate and other essential details.

'This stage will be quite a mess because I am changing and chopping and tearing whole pages out. It's a sorting process that I find worrying because I'm quite an orderly person. I'm not even sure if the characters or the novel will work, so it means a lot of anxiety. I'm usually quite miserable at this time. The anxiety usually lasts until roughly chaper seven. It's not until then that I'm OK. I heave a huge sigh of relief as I know then whether it's going to work or not.'

But before Wendy starts to write and gets to the reassuring seventh chapter she had a lot of thinking to do. 'I spend a lot of time choosing the characters' names. This may sound quite trivial, but it's a really important job. I can't use the names of people very close to me in case people think it's my daughter or husband. That's absolutely crucial. They are very important. When I've got the names it's a great relief. In

Breaking and Entering I called a character Dominic but then I decided I'd written about too many Catholics already, so I'd make him an agnostic. Dominic was too Catholic a name, so I changed him to Daniel – and I knew instinctively that was right. I can't explain it; I often rely on gut-feelings for my books.'

Wendy often deals with subjects about which she feels strongly. *Breaking and Entering*, for example, focuses on the question of whether there is anything beyond the material world, such as miracles and healing. 'I bring a lot of passion to the subject. My books come from something deep inside me, or maybe some event or dilemma I've read about or heard from friends. Something I can identify with. My second novel focuses on infertility and at the time I was trying (in vain!) to have a baby, which was both awful and funny. I put my own life in to the book because I could bring that much more conviction to the story, having experienced it myself – all the failures and frustrations.'

Wendy is fascinated by people with problems. 'I'm interested in writing about characters who are quite disturbed and I write much less often about normal, happy people. For one thing, I haven't been "normal" or happy long enough myself to know what it feels like, and secondly, I don't find those sort of people very interesting. Most of my friends tend to be a bit peculiar! I like writing about people living on a knife-edge, with difficult dilemmas, psychological problems, shaky marriages. Challenging subjects. That's what attracts me.'

The terrifying accusation of being in Satan's power initiated a fear in the young girl that has haunted Wendy ever since. 'I still believe in hell. I was very ill two years ago and thought I was dying and would be damned for all eternity. I was so frightened that once I'd recovered I went to a priest, which I hadn't done for years. I still feel angry that I lost so much of my youth to fear. In my novels I express some of my anger with the Church. Much as I would like to have my faith back and feel that the spiritual side of life is very necessary, the Catholic Church has done a lot of harm through its rigidity and the cruel ways it has treated children.'

But it's this anger and intensity that Wendy brings to her characters. 'As a writer it helps to have gone through a lot of

pain because you can use it in your work. If you haven't suffered, it would be very difficult to express in a novel the extreme grief or loss of your characters, because you couldn't really imagine what it would be like. Personal pain can be viewed constructively, because you can reach others through your own experiences. People have written to me, for example, saying they've been touched by the way I've handled bereavement.

'I don't really think the pain of death or divorce ever goes away or even lesser griefs. It comes and it passes. I had a very sad miscarriage – I wanted that baby desperately. It was traumatic, very painful physically, much worse than actually giving birth, and went on and on all night. I was lying on a trolley bed in a passage in an NHS hospital, because there were no beds left in the ward. It's always stayed in my mind, and when I wrote about a miscarriage in *Born of Woman*, I could recall the pain and sense of loss and my feelings of failure as a woman. For a writer, those things don't really dim. You keep your experiences alive, unlike some people, who prefer to be ostriches and erase them from their minds.

'Part of a writer's task is to make pigeon-holes in your head to store the memories. It's important to remember events such as having a baby or attending a close friend's funeral, because you may want to pull them out and use them later on. Don't allow these memories to pale; keep them sharp. Cultivate your memory.'

Many writers such as Virginia Woolf and Penelope Lively have kept a journal and it's something which Wendy does too, having moved on from the diary she kept as a child. 'I never experience an important event without recording it. Otherwise you forget the detail. A close friend's husband tragically drowned and shortly afterwards I spent the day with her and she was looking after someone's baby. The washing machine was tumbling away in the kitchen, the oven was on, she was feeding the baby and her own children were also there. Life was going on in all its ages and stages and then she suddenly said, "Oh God, that plant's dead", and it struck me as extraordinary that her husband was dead but she was worrying

about the plant. That might become a poignant detail in a book. If I hadn't recorded this in my journal, I wouldn't have remembered those little touches.'

With her friend's permission, Wendy included this incident in *The Stillness, the Dancing*, in which the heroine's lover dies. In the novel Morna's pain is concentrated on a cut finger. 'At the exact time my friend's husband died, I cut my finger and associated the pain of it with the sharpness of my friend's grief. I then used the idea of a finger which wouldn't heal as a sign of Morna's continuing grief in the novel. It's little things like that which add more subtlety – an outward symbol of what's happened to her whole inner psyche.

'It's as if the writer is a magpie, collecting everything taking from other people's lives. People often say, "Oh, don't put me in a book", and actually, I've never put anybody in a book, but what I do is put bits of people in. So we are unpopular birds, we thieves. Anything that takes our fancy we've got to have for our nests.'

Before writing a new novel, she sorts through all her notes and cuttings in the folders, but surprisingly doesn't ponder on them for too long. 'I don't take more than a week or two to go through the notes, as I've thought about the book long enough already in my head. I still don't have it completely worked out in my head, but I do have the main ideas.'

At this stage, Wendy will finally begin writing because she says she has to get the tone of the book, pointing out that it is very different in each novel and must be appropriate. There is a huge difference, for example, between the satirical tone and black comedy of *Fifty-Minute Hour* and the more serious style of a book like *Bird Inside*. Viewpoint is a closely aligned subject which must be taken seriously.

'From which viewpoint to write the novel is an important decision which every writer must make. *Fifty-Minute Hour* is written in a combination of first and third person, and past and present tenses are used together. It was done deliberately to give a sense of jolting and disorientation, because the characters are patients in psychotherapy and they've all got problems. The Nial character is written through the 'I' voice in the present tense, and the other two characters are written

in the third person and in the past tense.

'I once started a novel in the first person and wrote a chapter or two and realized it wasn't working. I then tried third person and it worked better. It was trial and error. At that early stage I'm still in a miserable state of confusion, which I loathe.'

Once Wendy has decided on tone and viewpoint, she works on the opening page, agreeing with all writers that it is vitally important. 'You must have a good beginning which opens with a bang, grabbing the reader's attention. I find it one of the hardest things of all. Several writers, including myself, are a bit superstitious, and might call on their guardian angel for help or indulge in a writing ritual. I no longer write in bed, but I am still so insecure.'

This is illustrated by a little tale. One day Wendy was about to begin a novel and was wearing a striking new housecoat of brilliant colours. It was about 5 a.m. and she crept up to the top floor to start work in her attic study. 'Unbeknown to me, our dog William had had violent diarrhoea, and I had walked in my long beautiful housecoat through the brown stinking pools! Instead of writing the first page of my novel, I was washing the dog, the carpet, the housecoat and myself. Being superstitious I was convinced this meant that the book was shit.' Understandable. 'Though actually it turned out all right.

'I'm a great believer in rituals, having been brought up as a Catholic. When I start my novel and see the blank white page, I always write the name of the book (or the number of the book if I don't know it), the date and then Chapter One, as if to prime my subconscious.'

And she has to psyche herself up to start every novel. 'I make sure that nothing too upsetting is going on. If I'd just had terrible news or my daughter had broken up with her boyfriend I wouldn't do it. I try to be calm and positive because the task is daunting. I am about to begin a huge undertaking which will last anything from a year to two years and during this time the mortgage and the bills have to be paid. I have to believe in it and I am the only one who can – no one else knows what I am doing.'

Aspiring novelists should be realistic about what they are taking on. 'It's a long arduous task and you need the

discipline, control and energy to carry on through a bad patch. There is at least one in every novel; a time when it's flagging, sagging, or a character's not working. You must be professional and look at it with a very cold eye. In a way writing a novel requires arrogance. You are assuming that you can do it and you may not be able to. But you need the confidence to believe in yourself.'

Wendy has now reached the all-important seventh chapter. 'I feel a lot better. At Chapter Ten I stop and read it back, not aloud but in a critical way to see if it's working, what's happening, and to get some sense of it overall. I'm asking myself, Are the characters alive? Is there enough light and shade? At this time I try to see that I'm not disturbed. I have to feel really fresh and give it my entire concentration and do not take any calls. What I think about the novel now is very important.'

Out comes the red notebook again. 'I jot things down or go back and write over my original notes. I might say something like, "There must be more humour here," or "The main character's fine but her husband is rather weak or a bit unbelievable". And I'll make a lot of notes about the continuation of the story. I might say, "This is fine as far as it goes but we need drama or whatever". When I wrote notes about *Breaking and Entering* I said, "The sex scene in Chapter Two is too brief and there are no sex scenes for a long time after that. We need an extended sex scene to show how the two main characters relate physically. And I also feel that we need more characters, but once the action moves to Wales there will be a lot more anyway."'

The subconscious use of the word "we" to describe how she sees the novel so far suggests a growing feeling of confidence. She feels more certain now, perhaps, that the novel will be published, and she wants to ensure that she is giving her readers the best book possible. She is constantly weaving in the details which make a work of fiction seem real – or true.

'Whilst writing the novel I've been feeding in various different cuttings, having saved individual files for certain stages of the book. When I get to a particular event – say Daniel's arrival in Wales – I'll get out my notes on my Welsh

trip because I would have gone there too, of course. There is usually a trip somewhere, whether it's Wales or Paris or Las Vegas and I research these places to see what they are really like and what they would be like for my characters.

'If I've been to Paris several times before I'll pretend I haven't, so that I can see it with a new eye. I'll steep myself in it, taking notes about anything and everything because at that stage I won't know what I want. I have to include everything, even though I may end up with a lot of material I won't use. If my trip's to somewhere like Las Vegas, I have to work extra hard as it would be too expensive for me to return there. The trips are enjoyable but they are not a holiday.

'I am working very hard as I can't relax at any point, not even on the journey, because I might want to include that in the book. When I'm on a Channel ferry, for example, I can't just have a drink at the bar and let the world go by. I've done trips in the pouring rain, standing on the top deck with my notebook open to the elements. I daren't miss it because I don't know what I might need later on.'

Wendy is so convinced of the value of this note-taking, and of personally experiencing some of the predicaments of her characters, that she is happy to become an amateur actress if necessary. 'The notes are often made under difficult circumstances. I went to Lourdes for *After Purple* because my characters go there, and I had to decide whether the things that happened to me should happen to them. My heroine had lost her passport and had no money, which meant that although my husband and I were staying at a reasonable hotel, my heroine couldn't.

'I called in at a very seedy *pension* and told the landlady that my husband and I were down on our luck and could we see the cheapest room she had. And we were shown up to a horrid room and the landlady was saying in French, "Madame, do you like the room?" And I was thinking, in the few minutes she gave me, cracked sink, wobbly chair, bed in the corner, no wardrobe – taking notes in my head and also trying to polish up my French. My husband provided a second pair of eyes.

'It's exhausting when you've taken notes on every single

thing you've seen and done for a fortnight, so if readers of this book have got any fantasies about sitting in a café and having a wonderful time, forget it. Often, you haven't got enough time or money to stay for long enough. We had only three days in Paris and I had a hell of a lot to do. You can't lie in bed. You need every available minute to get out and about and work through your list of what needs researching.

'It's hard work being a novelist. Some people say, "Oh, I'm sure I could write a book in my spare time", and some writers whom I admire tremendously, do just that. But you not only plan and write the book, you must also revise it. There are many different stages and you need a lot of discipline to get through them all.

'When I've come back from my trip to Lourdes or wherever, I get out the Lourdes chapters and look through all my folders on the subject and discard a lot, or maybe use it in another book. You have to decide what to use. Usually something is ditched, otherwise the book is weighed down with too many travel details, which would be very intrusive in a novel. From this point on the book gets a bit more difficult because instead of just writing it, you have to keep checking what you're doing and weaving all the different strands together and feeding in new details.'

There is light at the end of the tunnel, however. 'There comes a point after I've been working on a book for quite a long time when I begin to feel confidence slowly returning. I can see the book is working and that I've reached Chapter Eighteen or Nineteen or whatever. I feel a sense of relief; a lot of the book is there. At the same time I'm having it typed. I am lucky because my husband has a secretery who works for me as well, and once it's typed I can read through for errors or bad style, revising from Chapter One.

'By now it's really beginning to take shape. The typed sheets are mounting up to 200 or 300 pages and I'm approaching the end, which is usually written in a terrible scrawl. I always try to avoid obvious endings, and go for something unusual or even bizarre. This takes a lot of work but *any* end requires effort. You have to tie up all the ends, resolve everything. You can't just leave characters in mid-air,

not even the most minor ones. This usually means that a couple of characters will be tied up well before the end. You don't want a Dickensian finale where everybody is married off. But, rather like a composer of music, you're deliberately making sure that all your themes are resolved.

'My husband read the last chapter of *Breaking and Entering*, without reading the rest of it, and said, "This is absurd!" I was really upset. But I had to believe in my own finale. It's no good saying, "My husband thinks it's absurd and some of the reviewers will think so too". A reviewer of *Michael, Michael* called it, "Pretentious and over the top". I was really downcast, but that's how it goes. It's no good fretting about what they say. You have to believe in your vision – and I use that high-flown word on purpose. *Breaking and Entering* was about grace and healing and mystery, so I felt it needed an ending which pushed me to the limits.'

It is a magical time when Wendy finishes her book. 'At the end of a novel I feel great elation. I write "The End" like a child and feel like celebrating with Champagne. There is a wonderful sense of freedom and achievement. I've done it! It's worked!' Sadly, that is by no means the end of the novel, and deep down Wendy knows it's only the beginning of a new stage. Before it goes anywhere near a publisher she leaves the book for at least a week, if not two or three, and gets on with some other work, such as writing articles or short stories, or pieces for the radio. She would like to have a longer break from the novel but the pressure of the delivery date makes this impossible. She advises aspiring readers to set the book aside for as long as they can. 'It's much easier to really see it clearly then.'

Although she will have done several mini-edits while reading through the typed pages, she now does a complete reread with notebook at the ready. At this stage she polishes and tightens up her manuscript. 'As I'm reading, I make pencil corrections on the typescript of anything over-written; crossing through the wrong words or wrong punctuation. And then I stop to make notes. Against Chapter One, I might say, "Fine"; Chapter Two – "The opening's a bit weak"; Chapter Three – "A real problem here in the light of the end", and so on for every chapter.

'I then start the re-write, doing all the corrections, noticing if

I'd used certain words too often, and generally cleaning and tidying. There might be weak parts which need definite improvement and require major re-writing. But for me it's the nicest stage because the book is there. I know I've done it and this is really only tinkering. It's when I feel at my most relaxed in the writing of the novel.'

For some writers, however, revision is a nightmare, because the weaknesses of their book are glaring at them from every dot and comma. Some even lose sight of the plotline and characters altogether and wonder where the book is going. A numbing fear sets in that the novel they have spent years working on may not actually be worth the effort spent, even for themselves. They lose faith in their own book. Has Wendy ever felt like that? 'It sounds very immodest, and I don't mean to be immodest, but I haven't experienced that. I hope I would have realized much sooner that it was too awful to go on and would have rethought my plan.'

But Wendy has experienced problems with a novel. '*Born of Woman* caused me more trouble than any other book. I realized that it wasn't going to work the way I'd planned it, so I scrapped all I'd written and restarted it and then it was all right. I don't think writers should continue to the end of a book before realizing it is too bad. You should know that at a much earlier stage – unless, of course, it's your first novel.

'As a writer, you are wearing two hats all the time – the creative hat under which you must let your mind flow and not keep criticizing, and the editor's hat in which you need to be very critical. But you don't want to wear them together. If you don your critic's hat too soon you're not giving yourself a chance. You've got to be willing to let yourself write badly for a time. Don't give up in the early stages and say, "Oh, it's useless". Just let yourself write what comes. Get well beyond the first chapter.'

Eventually Wendy will feel as satisfied as she can be with her work. All the corrections will be done and she sends it to her agent, who will then forward it to the publishing company. She is, of course, already thinking about her next novel and always thinking about writing. She returns to a theme mentioned at the beginning of this chapter: 'If you're

very angry, write about that, if you're full of enthusiasm write about that.

'It sounds selfish in a way, but you've got to write for yourself. If you keep trying to think of the readers you will write some contrived thing that isn't really you. And also, if you are thinking of the readers, which readers? They are all so different. You will never please everyone. Write for yourself with an eye to giving the readers the best book you can produce.

'One of the jobs of a writer is to show things as they are. To cut through the deceit of advertisers and politicians. There is so much guff put out in the name of truth and all the time we are being pumped with lies in commercials, or in broadcasts and newspapers. Few people are redressing the balance.

'The novelist must have a beady eye on how things are. That's not to say you can't write about love – of course there's love which never dies – but there's also a dark side to it. I've just written a piece for my Oxford college magazine admitting for the first time that I made a suicide attempt at the age of eighteen. I hushed it up for decades, but with each year that passes, I can see that it's more necessary to be honest. If we were all more open it would be easier to live. There are many people pretending that they're fine, or that they're not taking drugs, or they've never had an abortion and never felt like suicide – but denial makes life worse for people, not better.

'When I was fifty and published *Fifty-Minute Hour* I knew I'd be asked on the radio whether I'd been in therapy and I decided not to hide it, as I had done previously. It struck me that fifty was an age where I could "come out". Perhaps I should have done so before. I feel better for it.' Being more open and honest, however, does make the writer very vulnerable. Yes, I am beset by doubts and fears, but probably we're all frightened at some level. Many people won't acknowledge it, but my advice is to get it down on paper. Use fear and pain creatively.'

Aspiring writers need courage if they are hoping to write seriously. 'You are revealing your own psyche. You cannot disguise yourself. People are going to see you in that novel. You are opening yourself up to public scrutiny. You are going

to be judged. Your writing will be judged. But the alternative – not to write if you have the gift – is much worse.'

There are ways of getting round writing about people close to you. 'I never write about anyone I know in the sense of incorporating them wholesale. John-Paul, the therapist in *Fifty-Minute Hour*, for example, was nothing like my therapist. But I might take bits of people, such as a man's hairy navel, or a friend's interest in scuba-diving. And, obviously, the things in childhood must affect you.'

Wendy says she's met a lot of men in her life who are extremely reserved and private people, and says she's interested in creating enigmatic characters. From her father she has acquired a hard-working, puritanical streak that contrasts with her wild ebullient 'wicked' side. 'I am interested in people who are split in this way such as Graham Greene, Tolstoy (who fathered 13 children on his wife and then decided to become celibate) and John Donne, who wrote impassioned poetry and then equally impassioned sermons when he was later ordained.

'I don't know why I seem to attract people who are reserved and unemotional – perhaps it's because I am very emotional myself. But I am fascinated by them; they are a mystery, they are a blank screen. What are they really thinking? You never know what Jean-Paul is thinking in *Fifty-Minute Hour*. You don't know whether he's a con man or why he went into the profession. The reader has to observe and hope that the character may give something away.'

The tension that can be created by using a dual personality can be very creative, says Wendy. She has observed the traits in herself: 'One side wants to go mad and wild and the other side is saying no.' She has used it to good effect in her work. 'In *Cuckoo*, it's very clear. The conventional Frances becomes wild and lawless Fran. I'm very interested in the effect of a name change. I've had three different surnames, because I've been married twice, and I can't really identify with the third one – Perriam – so my writing name means little. My first married name means even less, as I haven't used it for twenty years. I tend to use my maiden name more often now, but even that doesn't feel much like me anymore. Many characters

change their names in my books and I think that's a symbol of their different facets coming out.'

Wendy often writes about young women and teenage girls, so it has been a help to have two daughters. 'Every writer needs to keep in touch with what's going on now in the pop scene, art world, everything. There's a danger that you could become very middle-aged in your likes/dislikes and outlook.' Several of Wendy's characters are eighteen, an important age when they are passing from childhood and school into the adult world, making crucial decisions about their careers, their futures, their relationship. It's a turning point. Wendy remembers, 'When I was eighteen it was a period of great uncertainty and it's almost as if I'm going back to that age, reliving it, having another chance, or even making more of a mess of it, as in *After Purple* and *Michael, Michael*.'

When she is creating her characters, be they eighteen or eighty she avoids giving too detailed a description of their physical appearance, because it pins them down too concisely and doesn't allow the reader any leeway. 'But you must give the reader a sense of who the character is. You must, as author, have a very clear idea of what your characters look like. It's so important because it affects how they are. If you are a beautiful woman you have a completely different experience of life than if you are plain. A stunning woman is used to being spoilt, noticed and always has a choice of men, for example.'

So how can aspiring authors escape those lifeless reports of blue eyes and brown hair, the lop-sided grins, granite jaws and flowing locks? 'Making things fresh is one of the greatest challenges in writing. Observation is initially important. We might describe someone's hair as brown, but if you really look at hair there's every shade of brown and every sort of hair from thick to fine. I am totally against such standard phrases as "twinkling blue eyes", "mane of black hair", "tinkling laugh" etc.'

Use your eyes as an artist does, Wendy advises. Concentrate on one or two unusual things which define the character. 'It could be something about their eyebrows – they are flatter at the ends, for example, which gets rid of over-used adjectives

like "bushy", or a woman's pretty slender hands might be contradicted by ugly bitten nails. Hands are important, possibly giving us clues as to the person's character, or even occupation. Such telling details convince the reader that the novelist really has looked at the person and not just lapsed into commonplace clichés.'

She points out that descriptions of clothes add another layer to the character; they aren't just coverings. In *Bird Inside*, Isobel wears a strange combination of clothes mixed up from different seasons – woolly socks with a cotton skirt, for example – that illustrate her scattiness and bohemian nature. People's possessions can have a similar function. 'My editor, Patricia Parkin, was very upset by her mother's death because they had been extremely close. When she went through her things she found a purse that had been repeatedly mended with old lady's cross-stitch. Patricia had given her mother a new purse, but rather than use it, she'd kept it for "best", put it away and then died. Patricia agreed that I could use this in *Breaking and Entering*. Details like this say an awful lot about character without actually spelling it out.'

An important facet to be considered is the relationship between the reader, the narrator and the characters. Wendy has said that at the beginning of a novel she is very careful about her choice of viewpoint. 'Some writers write as the omniscient narrator – the book is being told by the writer. But in most of my novels there isn't really a narrator as there is in one by Jane Austen; there is no "Dear Reader – look at this". This is more Fay Weldon's style. Fay wants to put across very strong personal views on feminism, or therapy or male/female relationships, so she will come into the story as Auntie Fay and give us her opinion. I enjoy it in *her* books, but I would never do it myself.

'Most novels are written from somebody's point of view. In the case of *Bird Inside*, it's written from Jane's point of view. We don't know what's going on in Christopher's mind or Isobel's. We see all the characters through Jane's eyes, which means that we may be duped as she is. I want my readers to believe that they are inhabiting a world which is entirely true. I want them to believe that Christopher and Jane are real

people, so I would never intrude as a narrator and voice my opinions. I leave my characters to speak for themselves. Christopher may make a statement to Jane which isn't true, but she doesn't know that and we don't know; we just have to grope along with her.

'Sometimes I've gone into the interior of every main character, as in *Cuckoo*. In a way that gives readers more understanding, because they're seeing each character from their own point of view. It's slightly more difficult to do. And I think on the whole I prefer to do a third-person narrative from one person's point of view as in *Bird Inside* or *Breaking and Entering*. It's slightly easier to handle.'

Wendy mentions that in her novel *Sin City* both the main characters, Carole and Norah, are presented in the first person. 'It was quite tricky to do because their use of language had to express who they were. One was a middle-aged mental patient and the other a rebellious eighteen-year-old. I wanted the reader to know immediately which "I" was speaking.'

To strengthen characterization, Wendy feels it is important to research her characters' working-lives. 'In *Breaking and Entering* Daniel works for a Third World charity and I knew nothing about that whatsoever. He'd also grown up in Africa, where I'd never been, so there was a lot of hard work to do. I wanted him to have a "do-gooding" job, so there was no way he could be a salesman or businessman. I had to go and talk to people who did that kind of philanthropic work and it was a completely different world.'

Asking for help can be difficult if you are not a famous writer. Wendy advises, 'Aspiring writers could offer to take the interviewee to lunch and fit in with their timetable. Even quite eminent people are often quite glad to talk about their work.' Professional bodies will always send the writer free information, Wendy points out, which is a very useful research source. 'But aspiring writers must ask for every reference book under the sun for Christmas and birthdays. Even if you are a first-time author think of yourself as a professional who needs the tools of the trade. Try jumble sales if you are broke.'

How should a writer approach timescale? 'It's essential. It's easy to get muddled, but you must fix on a timescale. It can be anything from a day to a lifetime, but it is very important. A year is a long time for a young person. Someone who goes up to university at eighteen will be a very different person at the end of that year – they may have gone on to drugs, had their first sex or overdraft and all that will have changed them. Change is vital in a novel. Characters must change by the end of the book. It's very important to keep a diary or calendar, so that you know where you are in the novel. I always note the day, date and time of every chapter. A summer Sunday evening is entirely different from a snow-bound Monday morning. Another point to consider is whether the season outside is the same as the one you are writing about. You need books and photographs to look these things up as you are often writing against the seasons.'

At what stage does she know what the time-frame of her novel will be? 'For me it's secondary to the characters and the plot and comes at the stage when I get my notebook out. The length of time it takes for a relationship to develop might give a sense of time.'

How does Wendy cope with a real-life present which changes? 'As a novelist I think you make a choice. Am I interested in how society has changed and therefore want to write historical fiction? Or am I interested in how people change within the scope of the book? Do they experience emotions – love, hate, death? My real interest is in people and I've no desire to go back in time, not even into the recent past.'

Writing, if you hadn't realized it already, is an all-consuming part of Wendy's life. 'There comes a time as a writer – and it happened with my fourth book – when you start to dream your books. They become so much part of your life that you begin working out words and problems in your sleep. It takes over your life.

'Some people say that you can only write if there is something wrong with you – normal people get on with living – and maybe they're right. There are an enormous amount of unhappy, neurotic writers. If you look back into the past, a

very high number of them have been alcoholic or suicidal or manic-depressive. I've heard some writers say, "I wrote until I was happy and then I stopped". I think Freud was right when he said that writers try to make recompense for a sense of guilt or inadequacy, or for problems in their childhood.

'Writing is a strange job. I've always felt that things aren't quite true until I've written them down. I must believe in my novels utterly. When I finish a book, I want to think, "Yes, that was as true as I could get it". It is untrue in the literal sense, but as the saying goes, you can often grasp more of the truth in fiction. However messy your own life has been (and many writers lives are very messy, including mine), when you produce a book it has form and shape; it's not a wreck.'

9

Craig
Thomas

'As a professional writer I am always looking for ideas for books and therefore they come. It's the mysterious but easiest part in a way. An idea often strikes me from a newspaper account or from one of the more specialist publications that I subscribe to, such as the *Economist's Foreign Report* or *Jane's Intelligence Report*. They often have small items of news about which one might speculate. It gives me a situation or place or possible area of conflict.

'I don't look for specific incidents or areas that might suit my run-on characters such as Kenneth Aubrey and Patrick Hyde, who appear in several of my books. I just look for things that interest me. The most important lesson I've learned about being a thriller writer is when to discard ideas.'

Craig Thomas's methods of research differ depending on the kind of book he is writing, whether it requires technical knowledge, a convincing political background or a believable exotic locale. Who can forget the masterly description of the plane in *Firefox* or the submarine in *Sea Leopard*? But his basic writing method is the same from book to book: he is a compulsive planner.

Craig believes in the old adage, 'Write about what you

know, or if not, find out' – the rider being that is should be a subject that you have the capacity to find out about.

'I wouldn't have written *Firefox* if my oldest and closest friend hadn't been an ex-RAF pilot, who still had contacts in the RAF. I would not have thought of writing a book which required so much technical detail about flying an aircraft because I've never flown an aircraft. When I wrote it, I'd never flown in a jet plane, passenger or otherwise. You shouldn't write a novel which requires a lot of technical detail unless you know you can cope with it. You need to know where to get the information, or have friends who can supply it.'

But Craig has hope for the aspiring writer, saying that you don't need to find the ultimate expert. 'When I wrote *The Bear's Tears*, for example, a friend helped me with the passages about breaking into the Moscow central computer. He wasn't an "expert", but he was a computer salesman who knew a lot about computers. I just told him what I wanted to do and he worked out how we could do it.' He points out that most people know something about computers today or know someone who does, so it would be easier these days if the aspiring writer wanted to include computers in the narrative. 'Twenty years ago, you really would have needed an expert whereas today your friend probably knows enough.' This is indeed fortunate, as he doubts whether an aspiring writer could interest experts in helping with a first novel.

This doesn't mean you should give up, he says; simply plan a novel that doesn't require other people's help. He adds, 'Don't write a novel that is set in a place you don't know, or an area, technology, or military or foreign affairs that you can't find out about about – or worse – have no interest in.

'Later on, you can ring the MoD and say, "Harry, old chap, can you tell me about the Challenger tank", and they will probably trace your call! But you have to start somewhere. In *Rat Trap*, my first novel, accepted for publication when I was thirty-three, I had a friend, Roy, who had served in the army and another friend, Terry, who had been in the air force, so I could include a flying sequence and a lot of army ranks and manoeuvres, none of which I knew anything about, but they

did. They were friends, so I didn't have to go cap in hand to a stranger and say, "I'm thinking of writing a novel: can you help me?"'

When Craig started *Firefox*, he says that in those days the only useful books were Jane's. At that time he had to borrow from the library, because he couldn't afford the thirty pounds or so for a copy. Today he points out that you can get pop-up books on guns, planes and tanks from any good bookshop or reference library.

How does he do it? 'Once I have an idea for a novel, I see if it works. I say to myself, This situation exists. This person exists. This plane (or whatever) exists. What do you do about it? What is the story? What is the narrative which derives from the idea or contains the idea? So then I spend up to three months plotting the novel and changing it. It might change out of all recognition to the original idea, and it often does.

'Before I begin writing I need to have a detailed outline of the story. Some novelists go on a flyer or a note or two per chapter, but I like to know what each scene is going to be about, what's going to happen and who's in the scene. I might not stick exactly with my plan but I like the safety net. I need to know whether the idea has got the legs to carry it for fifteen chapters.'

Failure of planning rather than failure of talent or the original idea are the reasons why some thrillers run out of steam halfway through, he thinks. 'When I'm working out the plot I have an idea of the architectural skeleton of the novel in the sense that I know it will be in parts, probably parts one, two and three, or perhaps only part one and two. *Playing with Cobras* is a less complex story than *A Hooded Crow*, for example, and therefore it has only two parts while the other has three.

'In the back of my mind I have the idea that there are five or six chapters per part. I suppose I'm already testing the idea in my mind, "saying" to the idea, "You've got to provide me with two climaxes during the course of the story and a big finish. Now can you do that, as well as providing an interesting opening?" At this stage it's just an outline. But that helps me because then I can plan the book in sections.

'I usually have some idea of what the end will be. It's one of
the early elements I know. In *Firefox*, it was easy, because it
seemed to me there had to be a dog-fight between two
examples of this super-plane. It had to have a dramatic climax.
If you have a principal character, he's bound to feature in it, so
therefore you need to know roughly where it's going to end
and who's going to be there. It has to be the hero and the
villain.'

By using a two or three-part structure, Craig can see
whether the various sections and chapters of the story will
work. 'But if I say there are five or six chapters per part, I
don't necessarily think that there will be twenty to thirty pages
per chapter with four scenes of six or seven pages. It's not that
mechanical, but I do tend to plan them within each chapter.'

There is no need to structure his chapters with the rigidity
required of the Saturday morning film matinees, where there
had always to be a cliff-hanger; but he's very much aware of
the genre in which he is writing. 'I start by planning the five
chapters of Section one, before moving on to Section two and
three in the same way. In *A Hooded Crow*, for example, there
are three parts, each of which concludes with a dramatic
climax. The mysterious shipment successfuly evades Aubrey's
people at the end of part one, and again is smuggled out of
Venice at the end of part two, by which time we know a great
deal more about what is going on and thus how high the stakes
are if Aubrey and Hyde fail. The climax of part three is the
final confrontation between Hyde and his enemy, Blantyre, in
Namibia.

'There are probably two plot-threads, perhaps three,
running throughout the novel. The strands of *A Hooded Crow*
concern the political changes about to happen in South Africa:
the danger of smuggling weapons from a disordered Eastern
Europe to places like South Africa; high-technology
smuggling from the United States to Russia, and British
involvement in all the above; Aubrey's personal revenge
against the man who caused the death of his niece (in *The Last
Raven*).

'Each chapter is measured by the progress of the plot. The
first question I ask myself is how much of it and how far is it

going to be driven forward in this chapter? The second question concerns the balance of the plot strands. Am I going to have two or three of them in this chapter, and how many scenes are going to be allocated to each strand?

'The story can be driven forward with extreme efficiency by cross-cutting, which is the technique that Frederick Forsyth reintroduced into the thriller. It's the Graham Greene technique of short-scene cross-cuts – the movie style, if you like. So that's something I bear in mind during this planning stage. I then begin to feel which plot strand should dominate within each chapter. It's like a race with two or three competitors, where one is in the lead but can be overtaken by the other two. I begin to feel a sense of the balance of a plot, and since my motive for creating plot is excitement and tension, that's my guide and means of judging it.'

Craig often has his characters reading newspaper headlines or listening to television news broadcasts in order to drive the narrative forward. He says, 'As I write from within the viewpoint of one character at a time, he or she can be thinking about the headline or broadcast in a slightly fragmented way, for example, without me looking as if I'm obviously telling the reader what's going on. You can convey the essence of it without laying it out for the reader in neat paragraphs.

'Each plot strand must have variety. You don't want each plot strand to have the same kind of incident, locale, or number of characters per scene. I'm aware of these techniques but never forget that my demand for the plot I am creating is that it should be exciting, bold, driven, moving forwards and have momentum. If aspiring writers apply those guidelines rigorously, they should come up with a plot that actually is exciting.'

But there is still a long way to go before Craig starts writing, for he has to consider his characters. He says that part of the idea for the novel must take shape around the character – a type of person in a certain position, who belongs to a particular country or business. 'When I've got the idea for the book, I may not have a name for the him or her if I am inventing a new character, but I've got the idea for the character. However, Kenneth Aubrey and Patrick Hyde and

the other run-on characters who appear in several of my books are there from the beginning because they automatically slot themselves into the story.'

Sometimes he can visualize characters in his mind's eye but says, 'I hesitate to, because I usually tend to write about them from the inside-out anyway. And what goes on in their heads is more interesting than what they look like. I tend to know them, and eventually I see them, even if I don't quite at first.'

A further question Craig considers before he starts writing is viewpoint, which strongly influences the style of novel you choose to write. 'You should consider writing style in the sense of deciding viewpoint. Are you going to write a first-person narrative? Are you going to be the omniscient author? Are you going to be the author who knows all the characters – if you've got six characters in the room, the author is the seventh character, the one who observes.

'Perhaps you could consider writing from a halfway house, where you are writing from several people's viewpoints but only from one viewpoint at a time. That's the viewpoint I tend to choose. Readers can clearly see the change of gear half way through a scene if I change to another character. It may look unsubtle but it's important to me to make it clear that I've shifted to another character's point of view. I like that style, although I find it limiting in some ways. I can't: tell the reader what's going on in everybody's head – or even in two people's heads – at the same time; distance myself to comment on my characters; or relate relevant parts of their biography that don't appear in the scene or occur to them at the time.

'The advantages are outweighed by the fact that the reader is getting the character's reactions, thoughts, feelings and responses in a more vivid and immediate way than he or she might get if the author stands further back from the characters.'

Writing in the third-person using multiple single viewpoints means allotting a function to a particular character in any scene. Craig says that he writes from the viewpoint of one of the main participants. In *A Hooded Crow*, there is a scene in which Aubrey, a principal character, is seen from Malan's point of view (one of the opposition), whereas the reader

might have expected to see Malan from Aubrey's point of view. 'I wanted the reader to know what Malan was thinking at the time, for readers to be able to see what Aubrey looked like from the outside.

'If I had chosen the viewpoint of the omniscient author, I would have described Aubrey as a small uncertain figure in the chair, but I couldn't do that because I have chosen a different way of writing, so I had to have Malan seeing Aubrey as this small, old, impotent figure. Malan's contempt for Aubrey is shown by the way in which he sees him. But I was using irony here because the reader knows Malan's impression of Aubrey is based on a limited knowledge of him and he doesn't know the half of it. As the reader knows Aubrey better than Malan does, he or she is not going to believe Malan's impression of him.'

Multiple viewpoint also helps the writer to provide the reader with a greater number of more rounded characters, even in an action scene, he says. Whoever has the point of view in a scene is the more rounded character at that moment in time. The other characters only move or talk around him or her. They don't think at that moment, because they can't; Hyde, or whoever, is not telepathic. Using third-person narrative for an action scene is like watching the movies. The camera is the author's (and therefore character's) point of view.

Only when he knows the plot, plot-strands, characters, viewpoint and feels he has done enough research does Craig Thomas start writing, although he will have already been making copious notes. But even after he has worked out basic elements, the critical process continues. The overall 'feel' of the novel is important to keep in sight, and he often changes around the order of the scenes in a chapter, characters or plot strands, once he is clear enough what the plot is. If he finds himself lacking, he tells himself off, saying, That isn't exciting and you've got this big lump of plot to get across. He makes suggestions: You could do it by having two men sit down in a room and tell each other about it, which is extremely dull, often practised, and still dull, whoever does it. Why not break it up by having more people there so that it becomes a discussion rather than a narrative?

'There are certain elements to a thriller that you simply can't

ignore. You can bend, break and reinvent its conventions, but the readership has expectations of that genre, in the same way that a writer of westerns knows that fans expect the characters to wear stetsons. Readers expect elements of tension, danger, conflict and risk. You must ask yourself whether your original idea provides that particular kind of story. You must also have a big finish and I would advise against an anti-climax.

'You are playing with fire if your principal character gives the reader no chance to empathize with him or her. But don't believe that he must be the hero to end all heroes. He doesn't have to be Harrison Ford in *The Fugitive* or in *Witness*, the really good guy. He can be morally dubious or even cowardly at times. He can certainly be exhausted most of the time and not quite up to it and at his wits' end. But he has got to carry, if not a moral message, which is also dangerous, the reader's empathy to some extent. The reader has got to feel for him or her and with him or her in a way that that they don't for the people engaged against them. That is the one convention you dare not break.

'In a thriller, people are supposed to be on opposite sides, whatever those sides are. They are supposed to be engaged in conflict: that's the plot of Hamlet, anyway. So I'm not just describing writing the thriller. It applies to other genres; conflict is the essence of drama and the essence of a thriller is conflict. How that conflict is written about, who the characters in conflict are, and what they represent is another matter.

'You can have a character like Bulldog Drummond, for example, a contemporary James Bond or a very modern exemplar of the neo-fascist school of thriller writing where the typical hero is Arnold Schwarzenegger – nastier than the villain but we are supposed to cheer (which I deplore). But you don't have to paint your principal character or characters whiter than white.'

On the other hand, he points out, your heroes must be doing something right, with characteristics that may make them more honourable than other people. But if heroes and villains are all trapped in a moral maze, he suggests that the hero should still be the more sympathetic character, perhaps through showing that he's been trapped against his will into behaving in a particular way, for example.

Craig believes that the conventions for writing about the cold War led to sterility because everyone obeyed them. The KGB had ill-fitting suits and boils on the back of their necks and heroes were heroes because they represented the West. 'That was really child's play and sometimes it was quite often childish.'

Playing With Cobras is an example of how Craig disregarded this convention. In the novel, the 'opposition' was two Indian brothers, the Sharmars, who had made their money through heroin, but whose ultimate aim was the good of India. The irony of the novel is that Hyde, the 'hero', destroys the drug-running operation because the brothers interfere with his personal life rather than a desire to get involved in the affairs of Kashmir and India. His girlfriend has been imprisoned by the brothers in her attempt to rescue him, which draws him further into the action. 'The Sharmars are strangely idealistic crooks; they want to do the right thing for India.'

Craig gives a further example of how he has tried to disregard stereotypes through his use of the KGB officer Priabin in four of his novels. 'I've tried to make Priabin a more rounded and individual character. I gave him a kind of moral blindness, so that he didn't really notice the awful things the KGB did in the name of Communism. He is a likeable character who finds himself working against the system as much as for it.

'If you've got a character like Aubrey, who has been in many of my novels, the reader thinks he or she knows him well. He's not a caricature of the John Le Carré-style intelligence shit – a really nasty Whitehall mandarin of the secret world. Yet sometimes he's not a very nice man; he's a manipulator (although he has become more human as he's appeared in more novels). In *Firefox* he sacrifices that poor devil Fenton, who gets his face bashed in, just to get Gant into Moscow and make people believe he's been killed.'

Aubrey's first appearance was in Craig's first novel, *Rat Trap*, but because his publishers, Michael Joseph, wanted the book to be about twenty pages shorter, he cut that scene out because it wasn't particularly important. But Aubrey's disappearance meant that he could be brought back to life in a later novel.

'When I next introduced Aubrey in *Wolfsbane*, set in 1963, he was on his way up and could re-encounter Latimer, an intelligence officer from *Rat Trap*, both of whom would know another character, Richard Gardiner, from the old days of SOE, so that's how he got going, and then he appeared in *Snow Falcon* and other books.

'He's a silly pompous old fool at times but basically I think that readers empathize with him. He's a character that the reader is well predisposed towards and thinks they know very well already, so to introduce a stereotype against him would weaken the narrative. The whole story would be unbalanced.'

Aubrey's opposition in *All the Grey Cats*, Brigitte, has to be seen as a rounded character, notes Craig. A ruthless general in the East German secret service, she detests the weaknesses in her son when he tries to defect to the West, and yet loves him as a mother. In order that the reader learns something about her private life at the same time as the plot is being carried forward, she gets the message about the death of her son while listening to a rehearsal of the Berlin Philharmonic in East Berlin. Brigitte has to appear human, however villainous.

'You must have elements of character like that. The readers don't want stereotypes. They want action, tension, thrills and danger but they want to feel that from the inside. They want to feel that the characters engaged in events are people they know and people they can feel about. Whether they like or dislike them is another matter. They have to feel *something* about them.'

Patrick Hyde is a tough-nosed Australian working as an intelligence officer for the Secret Intelligence Service (SIS) in Britain and a character to whom readers certainly react. Craig explains: 'In *Firefox* Gant was the running man – the active figure – then it was Richard Gardiner in *Wolfsbane*, then Vorontsyev, in *Snow Falcon* [a Russian who was the principal character, and the first sympathetic KGB officer in the thriller]. I then began casting for a counterpart for Aubrey, someone whom I could use more than once. I was beginning to plan *Sea Leopard* and thinking about the home-grown plot, based in the UK, and decided I wanted a youngish character. But I wanted to avoid the insubordinate NCO figure balanced

against a toff that you always get in the thriller, but I needed to use that kind of character.

'My wife Jill and I had just been for the second time to Australia on a publicity tour and it thus occurred to my agent at the time that I should make him an Australian. I could see that it wasn't a bad idea. Perhaps he could come to the UK as a child, I thought. He could have that kind of Australian bolshiness towards authority, an independent streak – a man who would call a spade a spade and yet not be British – a foreigner in a foreign land.'

Patrick Hyde's invention had a spin-off. 'Most of my characters are professional agents of one kind or another, which can be limiting. This is why Ros, Patrick Hyde's girlfriend, started to appear in the books. I wanted to show readers that Patrick has another life and is a human being as well as being a professional agent and a danger junkie like the late Ayrton Senna or mountaineers.'

Craig does not usually base his characters on people he knows, but Ros is an interesting exception: Ros is alive and well and living in Melbourne. Does she recognize herself? 'I don't know – well maybe she does, although she's never said and I've never asked her. It was meant as a compliment. She's the sweetest girl imaginable; she does swear a great deal, but, like Ros, takes care of you. There are a few other characters, heroes or villains, that are people I've met or known; but, in a way, the world I create is entirely fictional in the sense that the characters are not usually drawn from life. They are meant to be lifelike and convincing but they cannot be read biographically.'

Tim Gardiner, the running man, Gurkha officer and untrained spy in *All the Grey Cats*, came to Craig because he had decided that half of the story had to be about the Gurkhas. 'As a son of Richard Gardiner from *Wolfsbane*, it was useful to write about him because I knew this would involve him with Aubrey [as he was his ward] and I wouldn't need to over-use Patrick. I have to say, however, that using an amateur is quite an old-fashioned element in a thriller. It goes back to writers like Hammond Innes, where an innocent and ordinary character

gets involved in the machinations of the plot. I wonder if I might have used that technique more than I have done in my novels. They are not spy novels – despite the fact that they involve spies – but adventure stories, and I'm considering using more amateurs in future.'

Several of Craig's novels involve the intelligence services of several countries, notably the British SIS. What are his contacts? 'I don't have any experience of the intelligence services, and armed forces or the diplomatic corps but my characters are not really based on people, with a few exceptions. I've had expert advice from various people in the services over the years but that's a different matter. There are one or two people who might look a little like them and behave a little like them who are the experts in the book.'

Why, then, do his intelligence scenes seem so believable? 'The fiction – the big lie – has worked! I've always considered the intelligence services much like any other corporate business or a branch of Whitchall. I just try to make it convincing. There are office politics, manoeuvrings, people of different values and outlooks. In *A Hooded Crow*, for example, there is an awful bloke, Orrell, who takes over, so very different a man to Aubrey that even the pigeons are looking disgusted on the windowsill outside. Orrell is a rugby club hearty, a "man's man". All the other characters in the intelligence service are Aubrey's people. But Orrell provides a contrast to Aubrey. He hasn't got Aubrey's elegance of mind, intelligence, cunning or morals.'

Part of Craig's talent is to guess what the conversations of the intelligence services would be if they were concerned with a particular area. 'I've always regarded them as a department of the Foreign Office that occasionally shoots people (to put it crudely). My job is to be informed and fairly perceptive about foreign affairs, so that I can guess how they would talk about a particular subject. I can make the characters seem like the British Foreign Office because I try to understand British foreign policy towards the area of the world that I'm dealing with. It seems to me that as long as you say, "Don't do anything; we might upset the trade with that country", you've more or less got the Foreign Office right. It may be a cynical view but it's a view many readers share.

'My job is to write about the world in which we live, because no art can be divorced from the real world. It would have no point. I write about the geopolitical world, the vista of major international possibilities, such as South Africa in *A Hooded Crow* or India in *Playing With Cobras*. The *setting* of the novel is the real world, or applies to the real world as a speculation or a possibility. Within that, the characters and their context are invented.'

As well as keeping in touch through *Jane's Intelligence Report* and *The Economist's Foreign Report* and various newspapers, Craig is a wide and avid reader. 'If you want to know how they spoke in a cabinet meeting, read Richard Crossman's diaries or Tony Benn's. They don't have to be relevant to the book you are writing but they give you the flavour of what it is like inside Number 10. (Not that I've ever done a cabinet meeting; there are too many people speaking at once for me!)

'But you can get hold of this information; you ought to, it's your job to do that, to try and get it right. One can make mistakes, and unless your editor is an expert, which he or she is not likely to be, they probably won't pick it up, so you have to. I don't see a great problem in getting the nuts and bolts of things which help to flesh out the fiction.'

Craig works office hours – 'Luxurious office hours, I suppose.' – typing up jottings from his notebook. 'I usually start at 9.45 a.m. and go on until about 1.15 to 1.30 p.m. with just a coffee break. Then I probably go on to any point between 4 p.m. and 5 p.m., depending on where I've got to. It's either four or five days a week, but I'm planning, thinking and refining at any time in my notebook. It is a job, so I pretend I've got to go to work, even though I am only going upstairs to my study.'

The writing takes six to eight months. Does he do any rewrites? 'Not of my own accord, although it doesn't mean that it's not sometimes necessary. But including the planning and research, it takes at least twelve months and probably a bit longer – about fourteen or fifteen months by the time that Jill, my wife and primary editor, has edited and retyped it.

'I probably do between eight to ten typed pages a day.

That's anything from between thirty and forty pages a week. If I didn't have any interruptions, it might take me ten or twelve weeks, but it takes double that time. I once tried an early version of a word processor, but I found the screen self-defeating. The words were cold and over there, whereas with a typewriter the words are here.'

Craig has help with his work from Jill. She explains, 'After John Knowler [the editor] died, I asked Craig whether he wanted me just to read through his next novel, which was *Moscow 5000* and published under the pseudonym of David Grant. I made tentative suggestions, writing down what I thought worked and what didn't, and it gradually went on from there. It wasn't until *Jade Tiger*, two books later, that I did a proper editing job on it, and it's what I do today. I never hear about the story while Craig is writing it, because I feel I wouldn't be able to gauge the entire impact.

'I read it and get an overall impression as a publisher's reader would do. Then I make various general notes and start doing the editing very meticulously. If it's an action scene, I've got to visualize the surroundings. I've got to be in it and with the character concerned. I've got to be part of it. If not, to me the book's not working.'

Craig rarely makes errors of continuity, Jill says. She demands to be engaged by every word in the book. 'I sometimes say to Craig, "What am I supposed to feel about him or her? What reaction am I supposed to be having?" I don't mind it being unclear on one page if it's explained later on. I make notes about these individual points as well and then Craig goes through all the notes on his own. At first we discussed it but Craig didn't like it because he felt he was in the headmistress's study!

'I also alter it on the typescript in pencil. If I think a scene isn't quite right, I'll say so and why, although it doesn't happen very often. There may be an occasional paragraph in which I think Craig's over-indulged himself in a purple passage. If I don't think a character would say something, I will say. I think I'm more of a help as far as women are concerned, although in general he's very good at dialogue. Craig agrees that, in common with a lot of men, he doesn't

write very well about women.'

Only when they have both agreed that the novel works will Jill type the final version, copying from Craig's typescript and the alterations. She types thirty-five pages a day or about 100 pages in three days, and usually works four days a week. But that's going at it, she says. The typescript is then sent to Rachel Hore, Craig's editor at HarperCollins.

Craig's writing method is virtually unchanged from the early days of his career; so how did he get started? 'I left the University of Cardiff in 1966 with an MA on Thomas Hardy and came to Stafford and taught at the boys' grammar school (as it then was), King Edward VI School. Then I moved to Lichfield to teach at the boys' grammar school and it was there I met Terry, who was then an art teacher (although he's since retired) but who had flown jet planes in the RAF. It was just happenstance. I happened to meet him and we happened to become friends.

'I was teaching, but in my spare time I'd written a lot of stuff for the BBC – mostly radio plays – all of which were turned down. I did a couple of television plays that were full of dramatic camera angles and brilliant effects like sepia-tinted colour, grainy newsreel-type film, that kind of arty stuff. A two-hander that was basically a series of phone calls. An adaptation of *Lord of the Rings* and a science fiction serial called *The Genesis Tapes* (which Jill still thinks is one of the best things I did before I started writing publishable things).

'Eventually, a scriptwriter told me that I was really trying to disguise a novel as a radio play and that I should really write a novel. I had the idea at that moment to try and do a thriller serial for radio – most of which was going to be set in Moscow – about the Israeli Secret Service trying to smuggle out a Jewish scientist. I turned that into a novel instead. It took eighteen months and when it was finished I could see that there was a lot wrong with it. But I got it finished and that was the important thing.

'Instead of working on it and polishing it and trying to get it ready to submit to somebody, I had the idea for *Rat Trap* because at that time there hadn't been a hi-jacking at Heathrow. I thought it sounded like a good idea. I wrote that

with Terry's help and advice on the flying sequences. We went to Heathrow and he told me how an airport works technically and deals with the landing and taking-off of planes.'

Having finished that first unpublished novel, Craig found *Rat Trap* much easier to do and quicker to write, taking only four months. 'I used to write in the staff marking room – which was windowless – and therefore hardly any other teachers went in there; they used to mark in the staffroom instead. I was usually on my own, with one strip-light, and very rarely interrupted. I carried my portable typewriter back and forwards to school with me and if I wasn't on duty at lunchtime, I could do half a page, and after school, if I had a spare hour before I picked Jill up, I could do two and a half pages, and another page before dinner. I wrote in all sorts of odd moments and in the school holidays. I learned the trick of turning it on and off like a tap. I'd breathe heavily and then start and tell myself to stop, making sure I'd stopped in the middle of a sentence. Next time I read back half a page to get back into it. I knew that I had intended to finish the sentence so what had I intended to say? It was so exciting to write the novel that it wasn't difficult to get down to it.'

Craig sent his novel direct to Michael Joseph. He didn't have an agent but says that if he had been more sensible, he would have acquired one. 'It's a good idea: after all, the agent doesn't make any money unless you do, and you get the next best thing to objective advice.

'While Michael Joseph counted Arthur Hailey and Dick Francis among their authors they didn't seem to publish any thriller writers, although they had in the past. I didn't see any point in sending *Rat Trap* to John Le Carré's publisher, so they could say, "Well, it's not like John Le Carré – we don't want that". So I sent it to Michael Joseph, which published popular books, but hadn't recently published a thriller writer of note. It wasn't that I assumed *I* would be their thriller writer of note; it was just that I wasn't trying to elbow my way in where Freddie Forsyth or John Le Carré were king. Collins already had Alistair Maclean, Hammond Innes and Desmond Bagley, so there was no point in sending it to them.'

Rat Trap was rescued from the 'slush' pile by a secretary,

who started reading it and who passed it to an editor. 'From what I understand nowadays, however, many editors aren't interested in taking a novel "off the streets" as they call it. They want it to come through an agent. I think that any aspiring writer should have an agent these days.'

At that time, Sphere, a paperback imprint, and Michael Joseph were part of the Thomson Group and worked in tandem. Craig thinks his novel was accepted because Sphere in particular, rather than Michael Joseph, were looking for a British thriller writer. At that time, Michael Joseph were publishing P.D. James, who had written about three books, Danielle Steel and Clive Cussler, who had just published *Raise the Titanic*. 'They had two Americans as their major authors and a detective story writer, so I think they were prepared to take a limited risk with a British thriller.'

Craig then moved on to what was to be his final teaching job, as head of department at a school near Walsall, and started working on *Firefox*. He remembers, 'Terry and I created the plane on and around his kitchen table after school. I used to pop in and see him on the way home. Jill was working until 5.30 p.m. as a secretary and I used to wait at Terry's to pick her up in town before getting home. We only had the one car, as you can imagine. *Firefox* was almost as quick to write as *Rat Trap*, taking five months.

'The story just came about by accident. The accident was the friendship in the first place that allowed me to write that kind of thriller. If I hadn't known Terry, I would have written a more conventional thriller like *Wolfsbane*. It was only one story, as I always describe it: the seventies version of stealing the secret plans from the safe. The plane was a high-tech piece of equipment in the first thriller set largely inside the Soviet Union. All of which I got from books ... you can't imagine a teacher spending his precious holiday money on going to Moscow – not in those days, four years before Brezhnev invaded Afghanistan – can you?

'*Firefox* is a chase story which lasts more or less 250 pages. That's all it is. I don't want to belittle chase stories, because they are not easy to write, but they are exciting to write, if you put enough incident and variety into the chase. What is *The*

Thirty-Nine Steps but the classic chase story of all time? Most of my books are chase stories – it's what I do, and I'm fortunate in having the facility to do it.

'*Firefox's* linear plot, which goes from A to B to C without distraction and deviation, was exhilarating to write. And perhaps that's what a new or aspiring thriller writer might think of tackling first. It's less complicated than plot, counter-plot, and who's doing what to whom and why, the machinations of government departments and secret services, and even exotic locales. After all, part of *The Thirty-Nine Steps* was only set in Scotland. It wasn't very exotic, even when it was written. The exhilaration in the narrative might carry the aspiring writer through the blank-page syndrome. My novels are chase stories, but they have become more complex as I've become more practised and since becoming a full-time writer with more time to devote to the planning and producing of a book.'

When Michael Joseph saw *Firefox*, Craig's impression was that they decided to pull the stops out to make it a bestseller. After all, if Sphere as a small paperback house, could have another bestselling author in their stable, so much the better. 'It was shown to an American publisher via their British scout, who was also one of the most brilliant and immensely respected editors in London – John Knowler. He died suddenly of hepatitis about thirteen or fourteen years ago and I still miss him very much. He was a wonderful man.

'John always edited from the inside of a story, never the outside. That is, he edited what you'd written in the spirit in which it was written to make the book better. There were no preconditions or preconceptions. He edited what was there with sympathy and empathy rather than taking an objective view of the novel.

'John thought *Firefox* had potential, so he bought it for a modest sum for an American hardback publisher and they sold the paperback rights for a lot of money. The American hardback publisher got half, my British publisher got a cut because they were basically acting as my agent, and I ended up with 40 per cent, which was enough for me to give up the day job. The novel was then turned into a film by Warner Brothers

in 1981, with Clint Eastwood in the starring role.'

When Craig sat down as a full-time writer at the age of thirty-four, he had already had *Wolfsbane* accepted for publication, and the first draft of *Snow Falcon* had been finished. 'My colleagues behaved impeccably at my news, which is a compliment to them (I think they were quite proud of me), but they certainly never gave me cause to think they were either envious or resentful in any way at all, and the pupils thought it was wonderful.'

When *Firefox* came out, Arthur Hailey, who was also at Michael Joseph, read an early copy of the book and rang Craig's editor, who was also his editor, to ask him how long and how many times Craig had been in Moscow to research the book. His editor delighted in saying "I don't think he's ever been there. He never goes anywhere". Today Craig does feature places he has visited, such as Australia for *Jade Tiger*.

Since *Firefox*, he has never looked back and is still writing. 'It's difficult to understand what the motivation to be a writer is. Persistence is a virtue. If you want something badly enough, I won't say that you'll get it but you will put yourself in a position of perhaps being able to obtain it. You do everything you can to make it happen.

'I have always loved reading, writing and talking about books, which is one of the reasons I became an academic. I adored poetry and still think it is the highest of the literary arts by far, but I can't do it. Perhaps that's why I admire it so much. All the poetry I've read has helped me with writing thrillers because metaphor and simile can pack things into small spaces in a thriller. You can indicate mood and character and atmosphere, which a literary novelist might take half a page to bring out. You can give a glimpse of it by the means a poet might employ rather than a novelist.

'Why one should want to turn experience or imagination into fiction rather than back into life, I don't know, but that, I think, applies to all writers. It is a profound mystery – or maybe they never grow up and stop day-dreaming. Initially, I was driven by a love of words, the way they can be arranged, what they can be made to say and the images in the imagination which they evoke. It's probably a drug to which

one becomes addicted. Conjuring with words was the attraction for me long before I wanted to write plots or about people.'

Once one has written in a particular genre, it is often hard to cross over to another. Craig, with his MA on Thomas Hardy, continues to write thrillers rather than literary fiction. 'Disregarding the financial rewards, I would probably have to make a more and more conscious effort to create a fiction of a different kind within a different genre. Having written four or five thrillers, you begin to get a kind of tunnel vision. Stories that you read or events you encounter in real life make you think of a thriller rather a historical novel, a literary novel, a psychological study, or a social history.

'As a thriller writer, if I see a man hanging about a street corner I wonder who he's watching or who he's waiting for, instead of seeing him as an emblem of the social malaise of England at the time or as a strange isolated indvidual with an interesting psychological disposition.

'Having started in a particular genre, one is confirmed in the practice of it, but there are certain things that certain writers can do and certain things they can't do. I think the cobbler should, and probably does, stick to his last. I do what I can do – chases. They don't have a great part to play in *Middlemarch*. Every two or three years, I open *David Copperfield* and when it says "Chapter One: I am born" and I read those first few sentences, I go green and hear my teeth grinding. I still think, If only. But there are things certain writers can do and things they can't.'

It's possible suggests Craig, that writers' imaginations are triggered by different stimuli. He cites Jane Austen as an example, saying that she is not awfully good at lower-class characters. She cannot empathize with or get inside them. 'There are poets who can't write narrative verse or narrative poets who can't write lyrics, satirists who can't write love poems and so on. The individuality of the imagination limits or sets it on a particular course. Finding out what type of writer you are is probably one of the most difficult things for the aspiring writer.'

Committed writers are not put off by failure, interruption or

even real life, asserts Craig; neither should they worry too much about imitation. 'To find the last with which to cobble is a process of elimination and imitation. You write in the style of the people you admire. The writer who made me want to write was Ray Bradbury. I devoured *The Illustrated Man* when I was about thirteen, followed by *The Silver Locusts* and *The Golden Apples of the Sun* when they came out in the fifties in Corgi paperback. I thought, Oh, how wonderful to be able to do that.

'The novelist I most admired for the way he dealt with Whitehall and the secret services was C. P. Snow, and he might well have had an influence on the way I treated that world. There was a programme on Snow when he died, just one shot of him coming out of his London house, walking along the street, and Jill said, "It's Kenneth Aubrey". And it was, except Snow was a much bigger taller man; but I realized that subconsciously I'd used C. P. Snow as the model.

'In that sense Lewis Elliot, Snow's narrator, is also Hilary Latimer, except that Lewis is a slightly diffident observer of events rather than an involved man like Latimer. There were also some really good books at the beginning of the seventies – *The Day of the Jackal* and *Tinker, Tailor, Soldier, Spy*, for example.'

Craig Thomas has this to say to aspiring writers: 'You have to be self-indulgent at the same time as being terribly self-critical. Keep those two personalities active at all times. You've got to believe you really can write a novel like nobody else because otherwise you will never actually get it done. You've got to believe what you do is good. On the other hand, be terribly aware of whether it is or is not, because it is easy to fool yourself, saying, "That's good because I wrote it; what more can I say?" You can coast and say, "Yeah, well now, that'll do. It's a chase, isn't it: what more do they want?" But ask yourself, Is it a chase you've done before? Is it well-described? Or is it too fragmented within the character's head? Is it really any good?

Craig Thomas was born in Cardiff in 1942, and educated at Cardiff High School and University College, Cardiff, where he took his MA in 1967. His five years at university, he says, 'sealed my fate in pursuit of a life connected with words and with literature.'

Apart from writing his thrillers, all of which have a background of geopolitical strife, his book of essays on political philosophy, *There to Here: Ideas of Political Society*, was published in 1991. He is at present at work on a two-volume commentary on the German philosopher, Nietzsche. He has completed his sixteenth novel and his current publisher is HarperCollins.

Apart from writing, Craig has a passionate interest in classical music, jazz and rock, and in cricket. He lives in Staffordshire with Jill and two tortoiseshell cats.

10

Fay
Weldon

'The writing of a novel is a peculiar business. You write to, for and at an unknown person. It requires an unconscious creative process and a very conscious editing process; without both these elements it would be difficult to write a novel which would hold the attention of a stranger. What appeals most to the reader, I think, is the unconscious element which allows him or her to understand what it is to be in somebody else's head. And the process, which is very slow, has to be self-assured, and that is hard to achieve. It is natural for the writer to be full of doubt.'

It's a process that Fay Weldon goes through on average once a year. 'My future is mortgaged to my publishers (HarperCollins), who like me to write one book a year. Sometimes I do, sometimes I don't; sometimes it's more. It's no use writing a novel if you have nothing to say or nothing particular to write about.

'But in order to empathize with others it's necessary to know yourself. Knowing yourself, of course, doesn't mean that you can necessarily turn yourself into a character in your own novel. Many first novels are indeed autobiographical, or are based on strong elements in a writer's life, or their own character and habits. A beginner writer would be well advised to note the difference between feeling it's enough to write

about something which is very personal to him and her, and making such a leap in communication that it becomes important to other people as well.

'Emotion can empower what you write, but it is dangerous to write about the detail of what it is which triggers that emotion. A simple history of personal distress seldom works well because the reader, rightly, gets a sense that they're being got at. If the writer merely askes the reader to listen to his or her woes and sympathize, no sense is being made out of those woes. There simply exists evidence of a person who is very distressed: they don't have to read novels to know such people exist. Why pay good money to read such tales? Answer: they don't.

'But indignation – social indignation, indignation for other people or political indignation, for example – can transfer very well on to the page. But, again, just because you feel something very strongly doesn't mean you have the courage and stamina to write about it and bring the reader to your kind of understanding of it.

'Writing a novel is, when it comes to it, an irrational process. A rather peculiar thing. A whole lot of words confined in a square portable box about things that have never happened. A novel is a package of lies, really. Lies and exaggerations. How else to define a novel? To me, a novel is anything which you can persuade a publisher to print and people to buy. Nevertheless, people appreciate them, and I suppose it's a convenient thing to carry around: a book; a little package of other lives. To open, and think someone else's thoughts, and trace the path of the imagination, if only as a rest from your own.'

Fay, at her home in London, tries to write something every morning but doesn't always succeed. 'At 10.30 this morning, for example, it was a nice quiet time and I decided to work and continue until 1 p.m. But I started calling friends on the telephone and that was it. Somehow the more carefully I set time aside, the less likely I am to achieve anything in it.

'I write everywhere. Sometimes at the table in my sitting-room, sometimes upstairs in my bedroom. I prefer to write in the morning, if only because I am closer to my

dreams. In this more unconscious phase, this half-rational, half-irrational creative activity is easier. The pushing forward phase is in the morning; in the afternoon I edit, feeling less accepting, more judgemental.'

Fay edits as she goes along. 'I like to get ten pages or so nearly right in relation to language, style and ensuring that I'm saying what I more or less want to say. If I don't do this, as I progress I sense an infinite amount of work building up behind me. Once I've done several drafts of those ten pages, I go on further into the text. What I end up with still won't be perfect, but it will be as perfect as it seems to me I can get it at that particular time.

'But when all the blocks of ten pages are fitted together, I still might find unevenness or something left out, so I go back and do what has to be done. I seldom start writing and go on entirely to the end, though that does sometimes happen if it's short; if I'm writing a short story for example. But normally there is a lot of editing as I proceed. I don't often do things out of sequence, although, having said that, the last novel I wrote was done completely out of sequence: a vast number of vaguely related passages which then had to be fitted together, and some abandoned altogether, but not many. Fortunately, they turned out to be reliable, these on-the-surface-associations that my mind was making as I was writing. I then applied some degree of reason to the problem and understood what it was that I was doing. But it was an unnerving process.'

Fay says that all her books start in different ways. Some are character-based, some are plot-based, some are rooted in ideas. Some, she says, develop into some kind of theory about human nature – but it's usually only after the book had been written that she can judge it in this way.

Praxis is arguably one of her most famous books – an 'ideas' novel. 'My books, on the whole, are not character based. *Praxis* is a concept of a person driven by a single word. If you look it up in the dictionary you will find it has a number of meanings which are related and yet not related. I thought how odd: one word, so many meanings, all interrelated. There was something to investigate.

'Praxis is a Marxist term: it describes the moment when,

say, the foreman, driven by oppressive forces, in themselves inevitable, finally cries, "All out!" and everyone has to down tools and walk off. It's a word used to describe the moment when something remarkable but inevitable happens, and you can't make it stop because you are both victim and perpetrator. It also means orgasm in Victorian literature, and it's a girl's name as well. The novel starts with a title, a mere word, and demonstrates, through the events of a character's life, how the various meanings of the word take effect. A peculiar way to write a novel.'

In *Praxis*, Fay writes about a character named after its title, and a series of events in her life, which end in culmination, praxis. In this case it was the killing of a baby in order that the protagonist could take on board the guilt which another woman was feeling. 'In the novel, I was moving her towards that point. I was very conscious of the effect of language in moulding personality – especially the female personality. But as I was revising, I decided for some reason to cut out the paragraph in which I made that point and listed the whole gamut of words and terms of abuse that men were accustomed, pre-seventies, to use against women – adulteress, whore, incestuous bitch, shrill, harridan. Nevertheless, I worked through these words one by one in the text, demonstrating how unfair these epithets would be. In the end, Praxis is called a murderess – can't be much worse! – for killing the baby, but how do we define murder? Perhaps rather it was an act of self-sacrifice. Perhaps we should see it like that. *Praxis* is both a fictional study of a word, and an answer to a set of accusations commonly and unjustly levelled at women. It was well described as a "feminist" novel!'

The President's Child, though a conventionally plotted novel, is unlike the work of many male thriller writers, who do not allow weakness or frailty in their heroes or heroines – or if they do, this is an excuse to kill them off. Fay, by contrast, here uses disability as a central theme. This subverts the particular thriller convention in which the writer knows more than the reader, and delivers plot points in a rational way. Fay explains: 'Instead of using a narrator, I put in the novel somebody who, by virtue of being disabled, is considered to

have extra knowledge and can be allowed to be wise. A book based entirely on plot is meant to deliver story; forget wisdom, forget comment. But this character is blind; therefore she sits in her chair and hears everything: she has special powers. It's a kind of fictional convention which belongs to another genre. The Sybil is blind but knows everything.'

The novel is about a woman who has an affair with a man who becomes a US presidential candidate; a child results. In general, Fay says that her characters are fictional and not based on people she encounters. But, according to rumour, a girl at the American Embassy did indeed disappear one day and was never seen again. It was supposed that she had had an affair with President Kennedy. 'I just thought how extraordinary ... What if...? but many novels start with a "what-if" energy.

'I read lots of thrillers. It's hardly strange that I should write one myself. I remember its origins. I had flu, and just enough temperature to make the mind feverish, but not enough to bring one utterly down. I had about five brilliant ideas – or so they seemed to me at the time! – and wrote them all down and posted them off to various people. Supposing, just supposing! And all replied saying "what a brilliant idea!" But it took me about five years to recover from that day because what had seemed like brilliant ideas were actually extremely difficult to work out. If an idea is on the surface convincing, you have Act One but not Act Two, and it all becomes a trap. I learned a lot from seeing what was wrong with "good ideas". The question I should have asked myself really was, How do you resolve this? Is there indeed ever any resolution of just suppose, what if?'

'The problem is that if the idea can too easily dissolve on the first probing; then what? You can play around with it, you can change this bit and that bit and indeed end up with a thriller. You can make the right decisions: is he going to kill her in the end? Is he not? When do we discover it's him? But how on earth can it be resolved? Many thriller writers have just such a problem when they get towards the end. How on earth do their characters escape, when all the forces of good and evil are pursuing them for all the wrong reasons? If there is an obvious

way of getting out of the situation, why didn't your hero or heroine think of it? If you, the writer, can think of it, why didn't they?

'The challenge is to set up a situation in which the answer to the simple question, Why didn't they call the police?, seems believable. And these days there has to be a very strong reason not to call the police, particularly if you are well connected.'

Praxis was a character based on a concept. The idea of *The President's Child* sprang from a rumour. So where do characters such as the She-Devil or the dastardly Leslie in *Life Force* come from? 'It's hard to tell. All people have much the same characteristics: we are species-driven. We share the same emotions. If there's something special about them – which suit me and my fictional purpose – it might, I suppose, be helpful to have parts of a real person in a novel. But I would hope that my characters seem real to the readers because they don't so much describe as focus the characteristics and qualities generally held. Fictional characters are far simpler than real people. They have to be recognizable from page to page whereas real people seldom are from day to day.'

Does Fay have a picture in her head of her characters as she writes about them? 'I tend not to as they are concepts, although they have more of a physical existence these days than they used to. I describe them because I have readers at the back of my mind, and owe them at least that. If I see one of my books televised or filmed with a particular actor or actress, whenever I think of the character thereafter, that's who I see. I think of Julie Wallace of TV as the She-Devil rather than Roseanne Arnold of the film because it seems to me that Julie did it better. Mind you, she was given better lines.'

Fay disputes the advice often given in books on writing that the characters have to change by the end of the novel. 'There is no "have-to" about it. They do not have to change. There is no obligation here. The idea that there is a way in which novels ought to be written has been entirely invented by critics. A novel is the sum of all the parts you can get through to the reader. If a character is exactly the same at the end as at the beginning then this may well be the point which the

novelist is making. There are no rules to writing a book.'

Having studied economics and psychology at St Andrews University, rather than English, Fay feels that she is less constrained than others by formal considerations of plot, character and narrative drive. An acquaintance of hers had studied literature for a degree and wanted to be a writer; she said it had been "a grave mistake!"

'If you were to attempt to do it rationally, it would not be possible to convey a sense of the people you see in your head. You have to take a mad stab at it. I'm very much a writer who makes things up as I go along: the script editor's nightmare. If there is some detail which I find I need to know, I simply invent it, write it in. For example, if you wonder what kind of parents this or that person has, you answer your own question, invent and write in the answer. Writing a novel proceeds at an unconscious level in which you make connections with words, language and characters: and very often you only understand afterwards what you did and why. You don't stop to think about it in advance. Well, if you're me you don't.'

Fay finds the idea of a writer feeling obliged to do research for a work of fiction rather funny. 'Research is a very small part of any writer's work. People will certainly tell you that they are "doing research" but it's mostly a writer's way of saying, "I should be starting my novel but I'll put it off for a bit." My view tends to be if you don't know about it and you can't invent it, why write about it? I do look things up as I go along. Is that the same as "doing research"?'

Fay may not usually do research for her books, but acknowledges that *The Cloning of Joanna May* was an exception. 'That's the one bit of proper research I did do. Actually I was half-way through the book and was talking to my Finnish publisher who happened to know a professor of Egyptology at the University of Uppsala in Sweden, so I went to see him and he told me all kinds of things, some of which I put in the novel. Everyone assumed those bits were science fiction but they weren't: it is happening here and now. But it proved my point – the real world has very little place in fiction. If it's there, no one believes it.

'Things which happen in real life are without shape,

without precedent, without particular content. In a novel, however, the distinction between "ought" and "want", "should have " and "should not have", are important and to my mind is why people read novels and why they are an improvement on, or at least a commentary on, real life.'

Fay Weldon's dialogue is pithy, direct and active. How did she develop her ear? 'I've written a lot for television and the stage. My adaptation of *Jane Eyre* has just finished a West End run. I've been to more rehearsals in my writing life than I can count. You get the knack of it. Dialogue needs to be formalized and is seldom the language of everyday life. It's a matter of suggestion. If you are writing local dialect, you do it by putting one word in perhaps every twenty in local speech. If you try and write the whole conversation in dialect, the effect will be overwhelming, incomprehensible and patronizing. A word or two of dialect evokes the learned responses which listeners and readers have learned to make. "This is Yorkshire." "This is the working class." The writer sends out signals which relate to the world but are not reality. No one in prose work writes "nuffink" any more. Characters are not there to be diminished or insulted. Nor would you dream of instructing an actor to pronounce a word in that way. He must be allowed to use his skills. Good dialogue enables a cast to use their skills.'

If you get the dialogue right, the reader should not need to see the character's name printed on the page, Fay says. 'It is self-evident who is speaking. Each character's speech will be formalized, but formalized in a slightly different way. So within that formalization which is fiction, characters will be registered and recognized in the minds of readers and listeners.'

Like any other writer, there are days when she's on a rollercoaster: 'Of course I have peaks and troughs, I produce good paragraphs and bad, but alas, don't know until afterwards which exactly is which and, what's worse, I can't tell at all at the time. But when one edits, one's ambition must be to get things at least level. A novel is written over a long period of time, and you yourself change within that time.

'A short story doesn't involve so much editing. I often wondered why and then I realized that it was because it might well be written over only a couple of days and in that time nothing much in me may have changed. You will have the same approach, same style and same proportion of thought to language, ideas to language, over any single couple of days. A piece of work which is written over a long time will change as you change. That's why you can't just accept what you've written as gospel, which is what people who are just beginning to write often do. They believe that, because it's been so difficult for them to get it that far, the words they've produced are in some mysterious way sacrosanct and they cannot allow themselves to change a line. As it is written, so it must be.

'It's unwise ever to deliver partly finished work to publishers, to ask for advice. The idea is to get things to a point which gives editors as little opportunity as possible to change a thing. Because the more they change, the more the whole structure is likely to collapse. Your purpose should be to get a text to so perfect a state that nothing can be changed, nothing can be altered, without damaging the whole – so it would be a rash editor who struck anything out, and certainly one who was looking for an argument.'

That sounded a rather frightening assertion. 'It is.' Her voice had the steel of a writer who really cares about her work. Then she relented. 'But not necessarily. Many editors just like to get their oar in. They like to feel they are contributing. They hope to be helpful. Sometimes they are. They suggest changes and quite often I will do as they suggest, while suspecting that nothing is being made better, simply different.'

In order to get to the point of having an editor at all, of course, there needs to be a drive to produce work. I've often wondered, I tell her, whether if you don't have children, you can keep your creative energy for yourself. If you have children, isn't your creativity sacrificed with the sheer effort of bringing them up? The feminist writer gives an unexpected answer. 'I think that that notion springs from an old-fashioned concept of creativity. Namely that men had art and women had babies; therefore women were best not to have any truck

with art; they should find fulfilment where it was natural – in the kitchen and in the nursery. So it is a false and dangerous notion to see art and babies as mutually exclusive. And one that a lot of American women seem to hold, oddly enough. "Oh, I wanted to be a poet so I never had children." "I can just about squeeze in one baby but any more would use up my creativity." And some women even have a child and use it as excuse, and say, "Oh, I would be a wonderful writer if only I didn't have this child," and grow up to blame the child. Or even find they had children in order not to be obliged to write the novel, to put their ambition to the test. The fact is that women can have babies and novels in profusion; the capacity, in both senses, to create something which wasn't there before is merely enhanced. Do it one way, you can do it another.

'There may be practical reasons, of course, which do stop women writing. Shortage of money, which amounts to shortage of strength and time. Maternal guilt plays a part. Mothers these days do seem to be conditioned into believing that their babies should take up *all* their time and energy, leaving nothing over, or else they're failing their child. No child needs that. True, children need to be educated, socialized, trained, consoled, but they are not so easily damaged as young mothers suppose. You can leave the child with a friend for an hour or so a day, for example, and use the time to write. You can be a mother and find time for writing if you really want to, but not if you insist on being the child's practical and emotional servant.

'It depends on whether writing is to you an obsessive activity – in which case you'll do it – or whether it's just something self-congratulatory, when you won't. Console yourself with the idea that you have a lifetime to do it in. It doesn't have to be when the children are small – you can wait until they go to school or after they have left home. You can start writing in your sixties or seventies. There is no hurry about all this. Unless of course it's fame and fortune you're after – which should not be the writer's ambition anyway.'

I've often wondered, I tell her, whether a beginner writer with a good partner or husband would still want to write, or whether contentment would take away the inclination. And

what about new writers who are terrified their family or
neighbours might recognize situations or – worse – see
themselves characterized in what the writer writes?

'You don't have to write about domestic circumstances at
all,' she says. 'Your work doesn't have to be autobiogaphical
or biographical. If you're so nervous, write thrillers about the
White House or the KGB, if it so takes you. Better to get out
of domestic situations if you possibly can, anyway. Real life
makes bad art. A novel doesn't have to be built around your
own life; nor is writing one in the least neurotic. How is it
different from practising any other form? You don't paint
because you are unhappy, do you? Compose music because
you are wretched? You may not paint because you do not have
a studio in which to paint. And in order to paint you need
equipment and a room and somebody to pay for the room. For
women, affording to be a painter can be difficult.

'But all a writer needs is a pencil and a piece of paper and a
corner and nobody noticing and the desire to do it; that's all it
takes. If you found yourself trapped in a destructive
relationship, in today's idiom, you might indeed want to write
about it, but you might find it rather difficult to write well
because you wouldn't be able to get out of your own
circumstances or see them as others see them. Novels are not
sob-stories.

'Equally, you might be so blissfully happy that you tell
yourself you don't want to write and use that as an excuse.'
Fay adds, 'But I don't think these are questions you would be
asking a male writer.' I concur. Point taken.

We return to writing methods. Could she tell me a little
more about how she writes? I throw in an idea for a novel with
four strands so as to illustrate her approach. She begins by
asking me what the writer wants to say. Four things in this
case, I tell her:

1. Girl meets boy. She breaks off engagement in order to
 lead an independent life.
2. The contrast between the simultaneous appearance in the
 eighties of yuppies and wine bars and beggars on the
 streets.

3. Time – the perceived past affecting the shifting realities of the present.
4. A discussion: Do we have free will or are our lives predetermined?

Fay regards the four strands and says immediately, 'You've probably got four novels there but are trying to get them all into one. The first novel is about the broken engagement – boy meets girl etc. That's interesting and contemporary. I would see it as 'Girl decides that she should lead an independent life because a therapist has told her so and she believes him and puts her engagement behind her.'' That's a good novel and a socially useful novel because there are too many people who believe that there *is* such a thing as an independent life and who force themselves to be alone. Why do they do this? Because it profits therapists? Think about it some more.

'Why not turn the novel around, focusing not on the girl but on the therapist? If he influences this girl so much he can then look at the girl in evident distress and then say, "It's all my doing that she's alone. She's like I am, until the next one comes along." You'll need a background for this idea, but don't focus on that.

In referring to the second strand, I point out how appalling it seems that during the eighties our 'boom' society coincided with the first appearance of so many beggars, particularly teenagers, trying to survive on the streets. Fay suggests that the novel could be written from the viewpoint of the yuppie. 'It would at least get the writer away from a boring and conventional response. If everyone derides yuppies, find something powerful and passionate to say in their defence. Fiction is by definition subversive. And never, never assume when you write that readers have the same politically correct views as you do. If you maintain that beggars don't deserve what they get, you may be just echoing others, saying "Isn't this dreadful?" Everybody knows it's dreadful, but how many beggars or homeless people do you, for example, have in your house? That's the interesting thing – how we so seldom take responsibility ourselves, but blame others for the state of society.

'If you say "how dreadful", you are simply handing over your guilt to the state. You are saying, *"They* should do something", or "Isn't it awful how those people over there have earned their money? – it's money badly earned" – whereas it's probable that our money has been just as sinfully earned. Who owns the publishing house that prints this book? Do you know? Have you found out? Will you not take their money because it's tainted? I doubt it

'You're talking about a very old concept, of course – the Sumptuary Laws of the Church, by which nobody was allowed to conspicuously consume. People continue to "worry" about the yuppie who has a Porsche, but not about the schoolteacher who has a Fiesta. Why? A difference of degree, or in kind? What you could do in this novel is investigate your own shock-horror. If, as I suggest, you wrote your novel from the viewpoint of the yuppie, whose side you allow yourself to be on, you would find out all kinds of things about society and about your own assumptions and enlighten your reader, as well as yourself. Perhaps he finds that his brother is homeless but he can't let him into his house because he smells? Would it be an older brother or a younger? If you do as expected and write a beating-the-breast-about-society novel, you will find yourself short of ideas. If you write the unexpected, there will be no shortage of ideas.'

We agree that the third novel is to be the idea of the past intruding on the present. Fay says, 'That's the whole point about being a human being. If the past didn't intrude, you would act and feel as an animal does, without guilt and impetuosity. As human beings, we have language with which to define feelings and thoughts, and recall the past to alter the future; and our perception of time is very different to that of animals. So think about this: about memory, about time.

'You might recall that on TV last night you saw a brain-damaged man who has only a twenty-second memory. This man isn't happy: indeed he lives in acute distress because he is perpetually lost. Perhaps he could provide the basis for a character and you could demonstrate how the opposite – the ability to remember too clearly – is not necessarily attractive either. Perhaps the person who is in charge of this poor

creature hates memory. His patient longs for it but she wishes she didn't have it: it pains her so.'

She has another idea. 'Or perhaps you could talk about different generations, for example, and could consider writing about the parents of the characters you first started with, showing how the emotions of the past intrude on the emotions of the present. The cycles within which we all live.'

She offers another suggestion that might give an impression of the shifting perceptions of time within the novel: 'Perhaps you could consider not running the events consecutively and work out other ways in which you can account to your reader for changes in time.'

The fourth idea for a novel explores the extent to which we have free will. 'The idea people get that they are predestined to meet and love a particular person is common. But a belief in fate – or in reincarnation – raises some interesting questions. Who decides what our next life will be like? The boy did good, the girl bad? Is it a committee? Who decides that you are going to be a tree-frog and not a swan in your next life?'

Rather than just stating the obvious, or putting these questions in black and white, Fay suggests that the questions themselves could be raised in the form of a metaphor. 'Perhaps a male stickleback attracted to a red stickleback feels that it is destiny, but it could be just that the red colour triggers off certain behaviour in the other gender. With people, are you attracted to someone because their eyes are the same as your mother's? It could be anything. Perhaps it's instinct? The questing gene? The survival tactics of the species. The male instinct being to plant the seed and run and the female instinct to make him stay and build a nest. This is an idea which could run through all the themes you've offered. A flight to or from reductionism, according to your taste.'

Fay cautions against running all four themes together but says that running one or two together could work very well. 'You could interweave the stories about the wicked therapist and the girl, and the yuppie and his brother. Perhaps you could also then think about time, after all. Everyone has pasts. And this is how you write a novel,' she says. 'You understand you have, say, four different strands. You either separate them

out or use the facets of one to illuminate the other. Or you
could stick with those four separately and still turn out four
separate stylish novels.'

My response is that novels such as James Joyce's *Ulysses* are
multi-stranded – the journey of Odysseus, with its attendant
mythology, Bloom's vivid day, the experimentation with
various writing styles...

Fay says, 'I don't think that's the book you can write first.
Nor did James Joyce. You must remember that there was a
different kind of literary movement then (Modernism). The
"great" novels were written during another period in time
when people didn't have films or television sets. Novels were
written mainly about and for men. Times have changed. What
you have to do is write your own type of book: then you will
get a response.'

This raised a question. Is it that men are still aiming to be
clever, above all, with their writing – Julian Barnes and
Salman Rushdie, for example, spring to mind, with their
many-layered novels *Flaubert's Parrot* and *Midnight's Child-
ren*? I mention the writers I like – gutsy women like Lynne
Reid Banks with *Children at the Gate*, Marge Piercy's *Braided
Lives*, or Wendy Perriam *The Fifty-Minute Hour*, or Fay
herself with *The Life and Loves of a She-Devil*. All are
novelists who deal with sociological, historical and political
perspectives to varying degrees. But despite the fact that men
also cover these subjects, I can't help wondering whether
women writers are more in touch with life.

'I think women these days tend to have more motive for
writing and more opportunity, and even more to say, because
there is so much still left unsaid. There was a time when
women wrote only in relation to men because art was seen to
be male, but communication was allowed to be female. You
could make that distinction, I suppose. Men have art, women
have communication.

'I think men go on writing literature for a world which
doesn't watch television – they tend to write for a more elitist
circle. They like to keep literature for the educated: they don't
let the uneducated in. Women tend to just think, well, a
woman's a woman, and changes her status according to the

man she's with, and doesn't care about her literary standing so much. Or it may just be that men are better writers then women ... had you thought about that possibility? It may not be so immediate, obvious, but perhaps they do indeed have a different response to language ... or they just have more time to write. "Great" writers stay male. "Good" writers are often female.'

It has been said that Fay sometimes likes to tease the interviewer. 'I don't often do that when I am talking about books or literature or writing. But it's true that when interviewers are asking questions about my private life or domestic trivia, it's tempting to say whatever comes next into your head. The problem is that what you feel one day to be true is not necessarily the same truth as you locate in yourself the next day. Many things are partly true but very few things are the whole truth. So what you get on one day is very different from what you get on another day. And so you should. On the whole, I give a true account of life, by speaking and writing daily, and differently, each day.'